Contents

Part One - A Wildlife Sanctuary is Created

Part Two - A Year in the Life of a Sanctuary Gardener

Part One

Just Before Dawn

A nature sanctuary planted

May Parker

Whittles Publishing

Published by
Whittles Publishing,
Dunbeath Mains Cottages,
Dunbeath,
Caithness KW6 6EY,
Scotland, UK
www.whittlespublishing.com

© 2006 May Parker

ISBN 1-904445-28-4

Typeset by Ailsa M. K. Morrison

Printed by Bell & Bain Ltd., Glasgow

Part One

A Wildlife Sanctuary is Created

Chapter 1
A Sanctuary Purchased

The car cruised up the hill as we looked yet again for the Georgian Residence that was for sale. How many times had we looked over properties, only to find that the right property was beyond our means, or that the ones we could afford were no better than the one we already owned?

The estate agent's leaflet was clutched in my hand as without much optimism we prepared to view *Stony House*. We followed the dappled road that wound its way invitingly through the woods. On either side, huge trees reach out to touch their opposite neighbours, forming a green arcade. The houses are far from symmetrical: tall Georgian residences rub shoulders with tiny Victorian cottages. The fronts of the cottages show spectacular designs of red and black bricks with deeper red brick or slate tiles for roofs. A break in the trees reveals a large manor house. We stopped at a pair of period cottages a little further on, to ask the way. A stout forest worker, flat tartan cap askew, explained that the keepers of the wood occupy the cottages. There are no modern residences along this lane to offend the eye; even the post box nestles in the hedgerow like an overgrown bird box. Following the woodcutters instructions we passed two farms with no sign of life, apart from three black and white Friesian cows flicking away the persistent flies with their tasselled tails.

We finally tracked down the property described in the estate agent's leaflet: "Situated on a corner surrounded by 440 acres of ancient woodland, sheltering behind a broken-down wooden fence". To one side of the house stood

a wide range of outbuildings in various stages of disrepair. The lop-sided shack listed as a garage had no windows, its rotten doors hanging drunkenly on broken hinges and the roof patched with rusty corrugated iron.

We took the footpath around the side of the house, a muddy trail blocked with tangled brown skeletons of dead bracken and vicious thorny gorse. Four acres of neglected undulating land, covered in nettles and ground elder, sloped to a small stream. The pretty stream meanders along the south and west sides of the property, its banks covered in a host of ferns luxuriating in the damp shade, almost hidden by the overhanging bracken. At the end of what could be a lawn, a boggy area provided an abundance of water plants. The tall irises had a lush growth of leaves and I hoped that the flowers that would come later would be as prolific. We later named this spot 'Eeyore's Place'.

A single gnarled plum tree that still bore wasp-bitten fruit had its roots in sticky blue clay. A row of silver birch (*Betula pendula*) formed the boundary to the east, while a double row of wild cherries (*Prunus avium*) spread from the slope to the stream.

The birches cast only gentle shade, enabling the suns rays to reach the ground. Beneath the birches, grass maintained a hold dotted with *Fly agarics,* a beautiful fungus depicted in children's picture books — brilliant red flecked with white. On the bark of the birch grew the bracket fungus razor strop.

We stood silent, immersed in our thoughts. A sudden flash of bright colours plummeted down to a branch close by, one of the most beautiful woodland birds we had ever seen. Before we could speak, there were more flurries and two grey squirrels peered down upon us. The jay soared off into the woods, his blue wing flashes and white rump showing up clearly.

The obvious abundance of wildlife urged us to think hard. The possibility of a hotel with its own wildlife sanctuary appealed to us. I knew that my beautiful dream would materialise only after endless battles with the earth, struggles against the elements, and efforts to achieve an affinity between plants and wild fauna; the two are not always compatible. Would the rabbits devastate my heather garden; wood mice make a meal of my crocus bulbs, moles tunnel through my lawns? At the time of our decision to buy the property we had no idea that foxes, badgers and deer populated the woods.

Wheels were set in motion and not without a few misgivings we moved with our teenage son David, our daughter Michelle and the family's springer spaniel Bracken to the large cottage in the woods.

The deep gully, separating our land from the surrounding 440–acre wood, was filled with a motley collection of bottles, chicken wire, broken ceramic sinks, and the inevitable iron bedstead, all of which were overgrown with nettles and brambles.

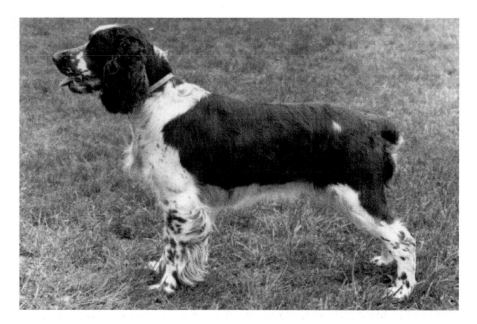

The area was large, with many mature trees and an exceptionally fine collection of rhododendron, which came from the Kingdom Ward Collection. A Mr Wood of the Royal Horticultural Society had brought them back from Chile, Burma and China. After their debut they were given to a professor of Agricultural Science who lived in *Stony House* and planted them in the garden. Unfortunately, the collection had been neglected for many years and there was a considerable amount of die back on each variety.

Somewhere among the trees lining the edge of the wood was a wire marking the perimeter between our land and that of our neighbours. We finally found the wire embedded in the old trees on the far side of the gully. That meant that the bank, gully and stream belonged to us — including all the rubbish. A fence of oak posts carrying three strands of wire marked the boundary. Some of the wire hung freely between the posts. Some of the posts hung freely from the wire.

To establish our boundary on the western side, we had first to clear the nettles, brambles and bracken that was growing without a break down the dip, over the rubbish and up again, far into the woods: a stinging sea, waving defiance at all our efforts to find the elusive boundary. An unexpected sound drew my attention, and I saw a water vole exiting his home. A hotchpotch of tunnels runs along the bank of the stream, their entrances lapped by water.

The trees at the east boundary were thinned, to let in light and create a wildflower meadow. We kept all the mature silver birches. Their silvery trunks and slender branches contrasted beautifully with those of the one and

only beech we process. It is known that the silver birch houses over 240 different species of insect and wildlife, a good start to my proposed sanctuary. It was beneath the birches that the bracken was most abundant, spreading rapidly in the acid soil by underground stems. Where the ground was wetter at Eeyore's Place, the bracken ended in a definitive line, preferring sharp draining soil. In this area are many grey-barked ash trees, each with a fine canopy of leaves.

The flora beneath the trees is a botanical delight. Four enormous ancient oaks with girths of at least ten feet stand alongside some young saplings of the same species. The oak trees (*Quercus robur*) support a vast population of wildlife. Some of the sycamores, although spectacular in autumn, were felled. They are of far less importance to wildlife and have a tendency to seed everywhere. I endured the hard work and kept in my mind a vision of walking along shrub-lined paths into the clearing that we would establish. I aimed to plant a very mixed assortment of other shrubs, as varied as buddleia, viburnum, blackthorn, hibiscus, roses, hebes, and honeysuckle. I wanted to ensure that there would be food, shelter, water and nesting sites, and banks of trees and shrubs that would provide deep secretive places where I could sit with my camera and photograph the wildlife.

Day after day we chopped, hacked and sawed; sweat appeared on our brows and blisters on our hands as with stubbornness we drove our unaccustomed muscles to the limits of endurance. We paused only for sleep and food. During the time we spent in the garden, the sight of many different birds that were nesting on our newly acquired territory constantly rewarded us. I decided to keep a book of notes and sketches to serve as a record of the wildlife around us; notes of an hotelier-naturalist as she went about her business and pursued her hobby.

By mid-April 1985 our beautiful dream house was almost complete. The lounge glowed in warm colours with deep gold drapes hanging from brass poles above the windows. All ten bedrooms had been refurbished, three of them as honeymoon suites with wooden four-poster beds, drapes and elegant furniture. Two of the three have balconies with a table and soft yellow cushioned chairs overlooking the sanctuary.

Any anxiety we had about the wisdom of buying the property for conversion into a hotel was soon banished; the hotel was proving to be a successful venture. In the pages that follow, I will describe the study of fox families and badgers, our acquaintances with the deer, the numerous birds, butterflies and moths, and how we planned and planted a sanctuary and garden for wildlife that grew from a vision and became a reality.

Chapter 2
Planting Out a Garden

It was a mammoth task. It seemed impossible that that neglected woodland with all its bracken, brambles and overgrown shrubs would ever become a sanctuary. I wanted woodland, clearings and wildflower meadows. I needed pools, an orchard and marshy places, perfume and beauty with colourful foliage providing a kaleidoscope of colour throughout the year but most importantly an increase in the wildlife population. My sanctuary would be a place where creatures of all sizes would be encouraged to visit. There would be birds to study in early spring when they are easily seen at their nest sites and a host of butterflies and moths to brighten up the borders.

The land took a long time to tame. The fact that the lower parts were overgrown with nettles, bracken and some superb ferns, helped us to decide where to start. We began at the northern end of the site with the heather bed close to the new extension, and worked our way down the slope and around to the west where we intended to plant an orchard.

I started with a plant of small heather brought back from the moors. A huge pile of peaty soil had been excavated in readiness for the foundations of a large restaurant that we decided to build. It rose mountain-like in front of where the new extension would eventually be, and seemed the most appropriate place to plant a heather garden. The variety of heather on offer is so immense I could have heather in flower every month of the year. It should be explained that all heathers have individual needs. Winter heather (*Erica carnea*) will tolerate alkaline soils as will tree heath (*Erica arborea*) and they both appreciate full

sun. *Erica cinerea* is found in dryer places than *calluna*. The variety *calluna* or silver knight has very soft grey foliage. *Erica carnea* changes colour in the autumn through green, soft yellow, amber and red: a jewel of a plant.

After careful consideration I chose heathers that flower in January, February and March when blossoms are scarce and colour is desperately needed. My selection included springwood white (*Erica carnea*), springwood pink and December red (which turned out to be mislabelled and is in fact a variety known as Pink spangles). I hoped to attract the Emperor hawk moth into the sanctuary by planting heather, as it is the caterpillar's food plant.

The soil in the heather border is basically peat but the sub-soil consists of sand and gravel, typical of the Thames Valley area. At the time of planting I was aware of numerous species of trees and shrubs that I would purchase for the encouragement of wildlife. Berried shrubs, cotoneaster, pyracantha, skimmia and crab apples were my first choice. I sent for the commercial catalogue of Hillier's Nursery, who provide shrubs and trees for businesses at reduced rates if sufficient quantity is purchased, and also for the catalogue of YSJ Seeds, an excellent conservation firm that specializes in native trees, shrubs, wildflower plants, seed and bulbs.

Whilst planting the heather garden, now named The Heath, I saw my first woodpecker: it was drumming on a dead branch near Eeyore's Place. At first I heard it but could not see it, then it moved, clinging to the underside of a branch. A scarlet blob under the tail and another on the nape of the neck indicates that it is a male; they are easy to sex unlike some birds. The female has the red underskirt but no other red markings and the young have red heads, which change to black as they mature.

A few dwarf conifers were dotted among the heather to break up the uniform flatness. My cypress 'boulevard' (*Chamaecyparis pisifera*) with its soft-to-touch steel blue foliage and lovely conical shape, blends with the white heathers perfectly. Among the pink heathers I have a Rheingold (*Thuja occidentalis*), another ovoid shape with vastly different foliage, rich golden-yellow in summer turning amber-gold in the winter, matching the colour of the heather foliage. There is also a dark green juniper (*Chinensis kaizuka*), a distinct form of architectural merit with long spreading branches, cut continuously for decoration. It never seems to resent this treatment and it grows so fast that frequent cutting is a good way to keep it in check. At the boundary is a lovely golden yew (*Taxus baccata Aurea*), one of the first plantings in the sanctuary. Originally twelve inches tall, it is now an impressive fifteen feet and covered in red fruit. At the entrance to the meadow stand two conifers with soft blue-green foliage, tall and slender. They are of the variety *Juniper virginiana Skyrocket*, extremely fast growing. They rapidly caught up with the varieties we had planted earlier. It is always advisable to resist the temptation of

purchasing large mature plants as they are always much slower to establish. The smaller trees always appear to do better than the larger ones, whose growth is inhibited by transplanting.

The garden cuts across a series of topographical regions. It includes the stream to the south and west, the wetland area, the meadow and Hazel Copse. After clear felling, the wildflower meadow had established itself and ran riot with bluebells, wood anemone and wild violet indigenous to the area. The field layer in our woodland contains a rich variety of plants that flourish beneath the trees where the light penetrates the canopy. In the darker corners, the shade-loving species such violets, dog mercury and ramsons thrive.

The site slopes gently onto a twisting path that wanders around the sanctuary and leads through the trees into the clearing. This open area, I felt, was to be the hub of the venture. From here soft mossy paths entice people to explore the sanctuary's depths. I wanted to be able to stumble across hidden badger setts, a group of snowdrops or wild cyclamen, small streams and flowering shrubs, all of which would add mystery and intrigue. It was my intention that the meadow would contain many varieties of wild grasses for the butterflies to lay their eggs. All species of jewelled fritillaries lay their eggs here in the warmth of the sun, with the exception of the pearl-bordered fritillary that lays her eggs in more shady clearings (the plants beneath the

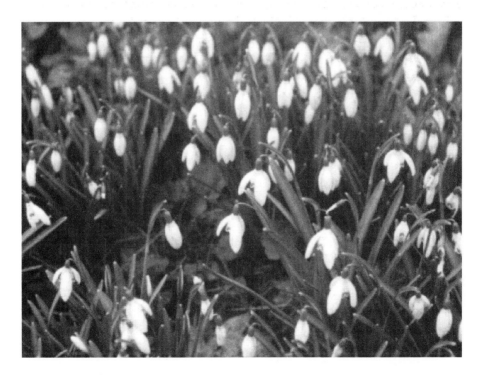

trees would be her choice). The meadow would have other plants: *Greater stitchwort*, daffodils and fritillaries. Cuckooflowers would provide a breeding place for the orange-tip butterflies.

The initial preparation of the site entailed the removal of perennial weeds. Annual weeds were dug deep into the base soil. That meant I had to pick out every piece of bindweed and couch. Bindweed comes up easily, but it also breaks off easily and it was obvious during the years that followed that some had escaped my eye. As I prepared the site, I was startled by the discovery of a nest of small adders, knotted together in a ball. Each was about six inches long with tiny zigzag marks, exquisite and glossy, running the length of each baby snake.

I spent ages searching for the grassy stems of *Fritillaria meleagris* that I had planted at the same time as the daffodils. These beautiful, fragile, checkerboard plants bring echoes of a bygone age and lost meadows. They are the only plants that I endeavour to protect from our guests, for they are difficult to spot. Bird watchers spend a lot of their time looking upwards, so there is a danger that these rare plants will get crushed underfoot. As soon as the stems appear in April, I rope off the area and place a sign saying 'Protected species'. This also safeguards the cowslips, which flower there soon after. Since its face-lift, the meadow has become an inspirational place for artists who are eager to transpose the various scenes onto paper.

Holly and ivy conjure up images of the Christmas season, but they also provide nest sites for the robins and blackbirds and berries for the fieldfares, blackbirds and redwings. Ivy starts producing clusters of berries once its flowers have been pollinated. By late February the berries will have ripened to a purplish-black. The holly is also the food plant for the holly blue butterflies larvae; she lays her eggs on the leaves. The spiky holly foliage prevents the deer from grazing them.

Beneath the trees the white veined foliage of *Arum italicia Pictum* spreads everywhere. The wild lords and ladies *Arum maculatum* spring up between, their glossy green leaves providing contrast. As I had succeeded so well with my heathers, a site was prepared near the glen for *Pernettya mucronata*, another peat-loving plant. Although extremely prickly it produces lovely berries the size of marbles in pastel pink, luminous white or coral red. Alas, one by one my pernettyas died as the soil, though peaty, remained wet throughout the year, which they dislike.

Since astilbes like waterside conditions (plants with spectacular spikes) I decided that they would probably succeed where the pernettyas failed. Now we have huge spires of fluffy wands waving at us. The *Astilbe fanal* is early

flowering with vivid red plumes. A white variety Deutschland of medium height is partnered by *Chinensis pumila* with bushy spires of mauve-pink, both plants flowering in midsummer. At the edge of the pool the dainty spikes of *Astilbe simplicifolia* sprite are only 9 inches tall. Their colour enhances the pink in the taller spires of *Polygonum superbum*. In just one season, the tree heath grew from eighteen inches to the height of a man. Its feathery arms are massed with tiny white bells, each rimmed with chocolate-brown.

Each plant to be introduced had to have a reason to be included in the scheme. There are two important aspects that contribute equally towards a successful habitat. Plants have to be provided for the adult butterfly so we can observe and enjoy their beauty, but we also have to provide plants for the caterpillar. The overall balance of grasses and plants is of significant value to what can be observed.

There was a need to divide the planted area from the wild. In a woodland garden, fences and walls are not appropriate. A hedge was clearly the answer, but it had to be informal and once again it had to have several uses. Shrubs play a significant part in a bird's life and I looked carefully at the varieties in order to ensure a plentiful supply of food and nest sites for the birds. Careful planning was required so that shrubs that flowered and provided fruit or coloured foliage were all included. I aimed to provide plants and security for all manner of things.

Even in its youth, the shrub walk had a richness about it. There are hydrangeas, silver privet, spotted laurel, osmaria, cotoneaster, shrub roses, hebes, spindle, euonymus, skimmia and pieris. There are daphne, berberis, wild privet, currant and enkianthus sporting urn-shape white fragrant flowers in spring. The scruffy *Lonicera* hedge particularly favoured by the birds will, with its uneven growth, give the project a more natural look. These shrubs are of great value: once grown, they would surround the old barn in the hedgerow, leaving a gap for us to pass through into my secret garden.

Another shrub that I purchased was *Potentilla fruiticosa*, commonly known as the shrubby cinquefoil. Its bright apple green foliage compliments the buttercup-yellow blossoms, and it remains in flower for several months of the year. The aromatic *Myrtus communis* was purchased at the same time; it flowers profusely in July, with pure white flowers from which a mass of stamens explode like a firecracker. In autumn it has purple-black berries. Growing wild along the hedgerow for our visitors to enjoy is the deliciously scented sweet rocket (*Hesperus matronalis*), sometimes nibbled by the wildlife.

During the bleak days the witch hazels brighten the sanctuary, when their bare stems glow with spidery blooms. As a ground-cover plant, the

fragrant *Daphne cneorum* trails along the ground beneath the witch hazels, its stems rich in cerise flowers. The Viburnums can be found in a wide variety. The variety *V. juddii* has blush pink flowers, which are delicately clove-scented. Our viburnums consist of *Viburnum bodnantense Dawn*, of a deeper pink. It begins flowering in October before the leaves fall and continues until March. *V. tinus* is a lovely plant clothed in white; it nestles close to the corner of our well house in which I have on occasions discovered tawny owls resting during the day. It remains in flower for several months of the year. At sunset, as the temperature falls, those plants open their blooms and are among the most fragrant of all, attracting the night-flying moths.

No other plant looks as natural as the wild honeysuckle dripping in long festoons from the tops of the trees in the sanctuary. Its creamy blooms diffuse a honey-like fragrance, attracting the lovely cerise and green elephant hawk moth. The powerful perfume of the night-scented stock *Mattiola bicornus* steals through the window at bedtime. This is a garden of dreams: not too tidy with woodland plants mingling with cultivated varieties in a riot of colour.

Chapter 3
Knee-Deep in Muddy Ponds

My garden sanctuary needed water. The tiny stream at the bottom was inadequate and dried up during hot summers. A natural hollow, caused by the change of level of the ground, provided the answer, and we decided to make not one pool but two. The pools would be connected by a slate shelf overlapping the second pool, and water from the upper pool would flow over this. An ingenious arrangement ensured that the two pools would not flood the sanctuary.

We started work on them as soon as possible. As the work progressed it was exciting to see the pool area getting larger and the mound of earth getting higher. By the end of the first day of work, the first pool had been excavated. The earth was piled up on all sides. The physical labour involved exhausted all of us and we could hardly wait to down tools. I hoped that the finished results would be visible from all the windows on the south side of the house.

A massive hoary oak stands guard over the lower pool, dwarfing it. This great oak, with its huge ivy-covered branches stretching up to the sky, provides homes and protection for a great variety of wildlife. The moss-covered deeply fissured bark gives this tree an overall phosphorescent appearance. It would not be easy to prevent the annual fall of leaves from contaminating the water. The permanency of the pools would however ensure visits from birds to bathe in the shallows. The increased population of wildlife would reward us for our efforts. A healthy pool would have a complex variety of microscopic life. Snails are important: they are the cleaners, eating decomposing leaves on the bottom.

Eventually and with much exertion, Tony, David and Andrew succeeded in excavating a hole to the depth of two and a half feet. The initial inch or so of topsoil gave way to yellow clay. At least we didn't have to line or waterproof the holes, which was encouraging news to the three intrepid workers. It was important to make shelves on which to stand the marginal plants. Rather than trying to construct them all around the perimeter, where only shallow shelves would be possible, we decided to make a shelf wide enough to take the largest pot with safety. This shelf would support pots of water mint, water forget-me-not and the exquisite Geum rivalis. There would be Marsh cinquefoil, Greater spearwort and *Iris laevigata*.

At the first suggestion of an early snowfall from the leaden sky, we turned indoors. Winter set in and some time elapsed after we started work on the pools. Snow lay deep in the hollows, the clear-cut edges of the pools were lost and I feared for the safety of the guests' children who might inadvertently stumble into a large snowdrift. Because it was winter, only a few people ventured out, but when the snow arrived it was different: both young and old seemed to revel in it. Finally the snow melted, spring arrived, the ground became manageable and work on the second pool was resumed.

A pool must have sloping sides to supply the all-important shallows on which wildlife depends. It is a place for spawning amphibians. The newts (like the toads for example) only enter the water to breed then leave the pools to hibernate beneath the rocks and stones. If well designed, the value of the pool is enormous. Essential to the pool is an area of beach with sand and pebbles to enable creatures to emerge with some safety and for birds to bathe and mammals to drink.

Oxygenating plants would be necessary to keep the water clean and clear in this potential wildlife haven. The first plant that we purchased is one of the most versatile and successful submerged plants: *Elodea crispa*. It has small dark green whorls of crispy foliage along its extensive branching stems and is sold as weighted cuttings with wire wrapped around the stems. It is simply tossed into the water where it will take root. Native plants are the best to buy, as they are part of our natural eco-system. The beautiful marginal aquatic flowering rush *Butomus umbellatus* attracts pollinating insects with its dainty rose-pink flowers and narrow foliage. The roots are a source of food for the underwater creatures and the stems are climbed by dragonfly and damselfly pupae, which emerge as beautiful winged insects.

I wanted to plant the border surrounding the pool with primulas, hostas, gypsywort, and yellow iris. A large clump of gardener's garters *Phalaris arundinacea* grows about three feet tall and runs the complete length of the

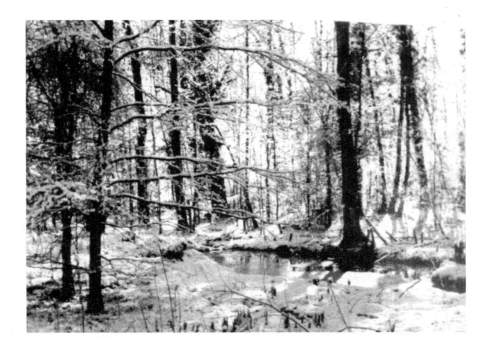

smaller pool. Although it is invasive, its variegated foliage is stunning and in the autumn the bronze colour of its dying leaves is in marked contrast against the gold-green conifers. The damselflies spend a lot of time laying their eggs on the surface of the foliage.

The leaves faded to a soft fawn by October and in May the new stems rose from the depths of the soft green, pink and white new growth. Only then did I remove the winter foliage, which had protected the tiny wood mice living beneath the rockery stones. The lady's mantle *Alchemilla mollis* with its beautiful fan-shaped leaves and soft yellow flowers was enchanting. Iridescent drops of water from the ever-flowing fountain lie captive among the hairy foliage. In the same bed is a *Berberis atropurpurea Nana*, its dark plum colour contrasting dramatically with the golden whipcord hebe. Pentstemon overlooks the pool and its association with a silver-leafed iris, *Pallida argentea Variegata*, delights me so much that I visit it regularly when it is in flower.

There was little space left for extra plants beside the pools apart from two horizontal conifers. Blue Star (*Juniperus squamata*), with silvery blue-green awl shape leaves and Grey owl (*Juniperus horizontalis*), a vigorous shrub throwing out soft green spreading arms to embrace its neighbours, add interest and shape and provide cover from the midday sun for frogs and toads. I found a spot close to the edge of the pool for Bowle's golden grass (*Millium effusum Aureum*) and a single plant of cotton grass. The shimmering white

heads of the latter have hairs that lengthen as the fruit develops. Overhanging the pool is a superb flower named Angels fishing rod (*Dierama*). The tall slender stems are strung with pink bells that are reflected in the pool. This lovely plant comes in shades of pink, purple and white.

The pool area has always fascinated me and since its introduction guests have spent many hours in loungers listening to the sounds of running water. It is a magical place to relax and admire the water lilies and marsh marigolds. Woodpigeons waddle in for a drink, and a handsome young fox lost his fear of humans during a particularly hot spell in order to quench his thirst. A gentle fall causes the water to drop in a sheet: a perfect miniature waterfall. A mallard duck was already showing an interest in the larger pool: a foretaste of what the fish could expect should we decide to stock it. The dwarf Japanese bamboo (*Nandina domestica*) with its colourful foliage had spread rapidly around the pools. I planned to dig up a large portion to transplant. Bracken tested the water by wading in and getting stuck in the mud. She made no effort to help me as I pulled her out, showering drops of crystal around, most of which landed on me.

The pools opened up a new dimension for wildlife and the observer. The life beneath the water could be recorded with the help of a net and magnifying glass. There was no need to stock the pool, wildlife would find their own way to it, and I was as excited as any child when I carried home from the garden centre my precious cargo of beautiful water snails. The ramshorn snail is the only variety that can be relied on, the spiral or painted ones are really plant pests. Unfortunately they seemed to be the main variety that garden centres supplied.

In one small pond there can be found masses of tiny creatures of different species, struggling to survive. The fine hairy roots hang down from the plants hiding the activity going on beneath the plants whose foliage covers half of its surface. Minute larvae of tiny creatures like water fleas, invisible to the naked eye, can be seen with the aid of a small lens. Dragonfly nymphs with large hinged jaws lurk in the undergrowth ready to launch an attack on their unsuspecting prey. The bottom of the pond is the home of some water beetles and the larvae of many kinds of dragonfly. A water spider rises to the surface to gather a bubble of air, which he takes down into the depths with him. When a newt breaks the calmness to snatch a fly, an ever-expanding circle of ripples mar the surface. The pond-skaters amuse the children as they can readily be seen on the surface of the water.

The lower pool at Eeyore's Place was never completed; it remained half the size that we originally intended. Tony enlisted the help of the driver of the JCB, who had been digging out the foundations of the new extension. However, the ground was so wet and swampy at Eeyore's Place that the venture proved to be impossible. The more the JCB bucket scooped, the faster the water poured in.

Finally the JCB sank lower and became completely bogged down in the centre of the hollow. But Eeyore's Place rewards us with moisture loving plants: meadow sweet with frothy white flowers, juncus (a type of rush), bog myrtle, hemp agrimony, astilbe and ajuga with handsome burnished bronze leaves and pyramids of blue flowers spikes.

The goat's beard (*Aruncus sylvester*) has beautiful flowers that hang down in a cluster and look like fluffy lambs tails, while creeping jenny spreads her carpet of gold between the tall marsh plants. It is an atmospheric place covered and enriched by dark green ferns, lichens and mosses. This area is the haunt of beetles dragonflies, and caddis fly larvae. Frogs gather here and can be heard croaking until late into the evening. Three weeks later the water had turned to pea soup: a natural phenomenon caused by the algae.

Eeyore's Place is a true bog, carpeted with bog moss, sedge and liverworts. The enormous leaves of the butterbur that I planted seemed to enlarge daily and showed signs of becoming too invasive but a small moth on the leaves encouraged me to keep it. During the day the moths gathered in droves above the huge leaves of the plant, in particular Degeer's longhorn moth. It is very small, only 1 mm and has a triangular shape to its wings when at rest. It is rich brown with a single yellow band over each wing, but the remarkable feature is the enormous length of its antennae; they must be three times the length of the insect's body.

There is an enormous population of annoying insects above the stream at Eeyore's Place and I wondered if I should place wire mesh over the entry and exit of the stream in order to contain fish and so keep down the insect numbers. However, I decided against it, reminding myself that my first priority is a secure sanctuary for wildlife. Dragonflies, frogs, shrews, snakes, toads and voles should be allowed to have this lovely stream to themselves. The natural effect had taken time and care. We could walk through the sanctuary and see dragonflies whirring like living jewels among the oak trees. They seldom visited the pool once they had pupated and become vibrant winged insects. They preferred to patrol the woodland where there is a great abundance of insects, returning to the pool only to lay their eggs. Delicate damselflies hover over the surface of the pool and I was content in the knowledge that another aspect of the sanctuary was complete.

Planting is a slow job and the finished effect is often not seen for a few years until plants have become established and matured. I find it difficult to explain to our guests that we cannot always ensure the presence of the wildlife. Some people visit our sanctuary and go away having seen nothing of the fauna and yet others arrive at a different season and are delighted by some rare and lovely sight.

Chapter 4
Experiments in Nature Photography

One morning I awoke to such beauty that it brought a lump to my throat. After several days of relentless frost the humble grasses were sheathed in silver. I took Bracken for an early walk before serving breakfast. Together we strolled up the bank of Hazel Copse: spiky fingers of the hawthorn caught at my sleeve as I passed. Stretched over the thorns of silvered needles, a glistening cobweb formed an intricate lacy pattern lit with tiny spheres of light. We were unable to walk quietly without disturbing the wildlife. Underfoot the grass scrunched but other than that there was no sound from the woods. I decided to return to the hotel for my camera.

During the harsh conditions, a marvellous star shape had formed over the bowl of the fountain. From each point hung long icicles almost reaching the ground, forming a structure of immense beauty. The fragile picture was soon destroyed by the sunlight as the icicles fell but remained upright supported by the snow, sharp and vicious like the jagged teeth of a gin trap. Finally, they fell to disarray on the ground below, where they lay glinting like a broken crystal chandelier.

I brought my camera into action to capture the spectacular moment. The mechanical device could record the picture but the drama and the movement were lost. The intense cold played havoc with my fingers and toes, my eyes hurt and my jaw ached. I found it difficult to work the shutter on the camera, and wondered how many birds had succumbed to the bitter cold during the night.

There was so much beauty to photograph in the sanctuary. I took two photographs of a pair of robins insulated against the cold with their feathers puffed out for warmth, looking almost spherical, their breasts glowing like fireballs. In the hedgerow I discovered a snow-lined nest. As it was winter the nest was unoccupied and could be investigated without any harm. Despite the cold, there were a lot of tiny parasites living within the twiggy structure.

I was soon to realize what a great element of chance there is in bird photography and discovered that to get good pictures it is necessary to stay patiently on the spot. I invested in a canvas hide (not a designer hide, they are far too expensive) and erected it in the meadow by my young sapling birches. I resorted to purchasing a toilet tent from a caravan accessory shop. Being a tall structure, we cut it in half to provide not one waterproof shelter but two. The spare material was used to construct inside pockets for film, seed, lenses and notebook.

The camera was extremely heavy: clearly a tripod was needed not only to relieve me of the weight but also to steady the equipment. The motor drive enabled me to take a succession of photographs at speed, and so eliminated the need to wind the film on. Over-excitement caused me to snap the shutter too quickly or to miss the bird altogether — I often ended up with a blurred image.

It was while I was photographing that I meet Tim Hallchurch who had recently completed work abroad, ringing birds. He suggested putting up some mist nets, in order to obtain some useful knowledge and take some photographs of birds as they were ringed and weighed. By mid-morning we had two nets in position, one near the food compound and the other by the bird table.

At the food compound, we caught and ringed: blackbird, bluetit, coaltit, fieldfare, great tit, nuthatch, robin, siskin and wren. At the bird table we caught and ringed: bluetit, brambling, chaffinch, coaltit, dunnock, great tit, greenfinch and thrush.

Other birds that we observed but didn't catch include: redpoll, collar dove, crow, great spotted woodpecker, jay, magpie, partridge, redwing, rook, tree creeper and woodpigeon.

We kept the net up for only two hours, as we did not want to prevent the birds from feeding for too long. The hours of daylight were short. The net holds a beauty of its own as the snow gathers along the mesh. It was still snowing when I went to bed; thick blobby flakes were falling at the window.

Note: It is illegal to ring birds unless you have a licence issued by NERC. You may use only official number rings, supplied by the British Trust for Ornithology, and you must be trained by a BTO licensed ringer.

Chapter 5
From Dusk till Dawn

I visited the garden centre at the bottom of the hill to list and price species of shrubs and trees complementary to the birds. In one respect I was very fortunate in that most of the soil analysis indicated that the soil was acidic, and it was also fortunate that the garden is sheltered by woodland on three sides. The trees calm the biting winds as they pass through their branches.

The first obvious choice for additional shrubs was buddleias: butterflies are drawn to them like a magnet. In June and July the blossoms are a spectacular sight, especially on *Buddleia alternifolia* whose cascading branches are wreathed with fragrant lilac flowers. Our orange-ball tree (*Buddleia globosa*), does not have the same appeal to the butterflies as the prolific white blooms of the late flowering White Cloud (*Buddleia davidii*). The White Cloud has a well-earned reputation as a butterfly plant *par excellence*.

On my list was the Japanese red maple (*Acer palmatum Atropurpureum*). It has bronze red foliage and needs the protection of other trees, ideal in our woodland environment. The deep red stems of dogwood (*Cornus syberica Alba*) and the pale yellow ones of *Cornus stolonifera Flaviramea* would flourish in the damp soil at Eeyore's Place. I also selected *Mahonia* for the rich perfume of its winter racemes of sunny yellow flowers and the highly fragrant orange blossom (*Philadelphus Virginal*) with its enormous clusters of semi-double or double pure white flowers for the perfumed garden.

For the herbaceous border I chose *Achillea filipendula,* which flowers from mid-summer to autumn in sunset shades and several Japanese anemones

to prolong the season. In the same border, purple loosestrife, pyrethrum, harebell and delphinium added contrast and colour. I included lupin simply because I like their towering colourful spikes and day lilies for a fresh flower each day, growing alongside blousy oriental poppies, Chinese lanterns, camellia, quince and Donard Seedling (*Escallonia*), an evergreen. Pansies with colourful faces and delicate perfume took their place next to the wild violets.

I planned on paper the entire year's upheaval — and upheaval it was for any plant that had been misplaced. Sometimes plants failed to integrate into the scheme, but only because of my own error or greed. I was unable to pass a nursery without adding yet another species to my garden collection. To make matters worse, a continual succession of catalogues fell through my letterbox, enticing me to examine their contents and covet yet more plants.

I spent a lot of time in the garden at dusk until early morning as the hotel took up most of my day. With those twilight hours in mind, I planned an evening garden. Some types of flowers remain open until darkness falls and others are more exquisitely perfumed at that time of the day.

It is worth growing the night-scented stock *Matthiola bicornus*. Its perfume is out of proportion to its inconspicuous lilac flowers, which open at dusk. The evening primrose (*Oenothera biennis*) opens up its bright yellow flowers from summer until mid-autumn, and seduces the moth population with its fragrance. The blushing pink variety (*Oenothera speciosa*) has a sumptuous lemon scent. Gorse (*Ulex europaeus*) flowers throughout the year and will grow in the poorest of soils. Its bright golden flowers smell of a mixture of fruit and vanilla which bees love, making it a good sanctuary plant. I considered first the paler colours that remain visible in the dusk. Even in the deepest twilight these night scented plants enthralled me. The highly scented mock orange blossom (*Philadelphus Belle Etoile*) flanks the *Philadelphus lemoinei*. Both engulf the sanctuary with delicious perfume. Among its dark foliage *Lavatera Barnsley*, a member of the mallow family, has a succession of white flowers with a dark blotch in the centre. Ghostly deep-cut lacy fingers of *Artemisia ludoviciana* attracted my attention, insisting that I purchase it. Also fragrant at dusk is our white *Datura*. Its sweetly scented flowers are flared, upright and bell-shaped. They have an exotic look of the Mediterranean.

To add poignancy, I decided to include the lovely *Lilium regale* whose perfume is so strong that it can be smelt from afar as well as the exotic *Lily muscadet*, my favorite with enormous heavily spotted blooms. They were planted in undulating drifts between the shrubs. There seems to be a colour rule for the intensity of perfume a plant produces. The paler colours, white and lavender in particular, have the sweetest scent. Hebes have many types and forms, such as the variegated leaves of the *Hebe variegata* and the taller Autumn Glory with

purple flowers. A favourite is Boughton Dome (*Hebe cupressoides*), a dwarf form easily mistaken for a bun-shaped conifer. *Hebe armstrongii* with stiff needle-like bronze coloured foliage was a later addition.

I moved several berberis bushes from the front of the hotel to a new position alongside the boundary fence. Not only would they provide shelter in the spring, but they are good hedging plants and can stand light clipping. They have yellow and orange-red flowers followed by small scarlet berries with brilliant autumn tints, and flower at the same time as the masses of bluebells in that area. The length of time a plant flowers is as important as its colour. Months of flower and foliage are better than a few weeks of spectacular floral display.

Originally, I had planted Blue Wave (*Hydrangea*) and bright *Schizanthus* on the sanctuary's edge, thinking only of a fine summer display. However, the sanctuary is also alive with colour in winter. Evergreen hollies and conifers guarantee all-year-round interest, and the berries are much appreciated by the birds. I am committed to providing flowering plants throughout the year and do not allow my sanctuary to close down for the winter. Mahonia, cotoneaster, cornus, pyracantha, evergreens, skimmia, pernettya, and winter cherries all play their part in the ecology of the sanctuary. Closest to the hotel is a shrub with inconspicuous flowers although its perfume pervades the air: the Sweet box (*Sarcococca hookeriana Digyna*). After the flowers have fallen it clothes itself with black berries. Inconspicuous though the flowers are, this shrub has the guests searching for the elusive perfume.

Crocuses make their appearance as early as January among snowdrops and winter aconites, all of which are good woodland plants. The herbaceous border is beautiful with old-fashioned lamb's ears that are lovely to touch, soft and furry and white as hoar frost. Later in the year tall stems of mauve flowers rise from the garden mint, perfect against the silvery-grey foliage. The mints, of which there are many varieties, are excellent insect plants. I love to see them covered with iridescent flies and hoverflies. The best edging plants are small and compact with plenty of leaves to conceal the ground below, and they must have a long flowering season. Clove scented pinks are ideal for hiding the harsh lines of the path and smell delicious. Dwarf Michaelmas daisies are excellent late flowering butterfly plants; they edge one of the borders with colourful daisy-like blooms. The sprawling Flashing Light (*Dianthus deltoides*) produces its blazing stars of red flowers so prolifically that it smothers the plant, concealing the edges of the border.

The shrubs and trees form part of the background. We have a fine row of gean massed with blossoms that float to the ground like confetti, after which the trees bear small dark fruits to be plundered by the birds in late summer. By the end of August not a single cherry can be found on the branches.

Chapter 6
The Woodlands Surrounding

The natural woodland around us extends to 440 acres and protects many varieties of plants, birds and animals. There are many exotic-looking fungi of weird and wonderful shapes and colours. They grow on leaf litter, fallen trunks and living trees.

Our land supports some of the finest oak trees — I counted thirty mature trees — most of which are growing on the western side. A single specimen of red turkey oak grows alongside the beautiful snowdrop tree (*Halesia styraceae Carolina*), hailing from North America. Every branch is laden with fantastic snowdrop-shaped flowers with centres filled with orange stamens. The copious nectar attracts the bees. Its beauty is in these flowers and the pale-yellow colour of the autumn leaves. Of the oaks, we have pedunculate and sessile oak, the plumpest acorns belong to the pedunculate oak.

I am particularly fond of the beeches with huge trunks that are easy to recognise by their smooth silvery-grey bark and their roots, many of which are above the ground. These trees have branches that sweep to the ground. During the summer, I creep through them to hide with my camera in a big green tent carpeted with leaves that have fallen the previous autumn. The beeches are at their best when the foliage is young: tiny green oval leaves, pointed and smooth-edged. Looking at the ground beneath the beech, many silky reddish-brown husks can be found. These once covered the leaves when they were in bud. By April each year, the fallen triangular nuts known as beech mast have all gone, eaten by squirrels, badgers and birds.

Growing near the stream is a splendid ash, tall and graceful with a uniform grey bark. Early in March the black buds can be seen arranged in pairs, and in April they burst into yellowish flowers. The leaves appear much later and the seeds of the ash are called keys; as they fall they twist around like a spinning top. The ash supports some wildlife but the oak leads the field with more than 350 species including many types of moths.

The wood is divided into many different areas. There is a grove of larches — a misty blue-green — and not far away is the pine grove with its spicy smell and thick carpet of sound-deadening needles. The spruces (grown as Christmas trees and cut down in December by the woodcutters) occupy a large area along with some Scots pine.

It was very hot one April afternoon when I was walking through the sanctuary. The wood was cool and inviting. I climbed the ridge where I had a spectacular view over the alpine meadow and could see a buzzard flying along the boundary. He glided on outstretched wings, keeping a watchful eye on the hedgerow ready to make an attack on his unfortunate prey. Badger Hollow is lined with acid green mosses. Several times I have observed the prints of a fox's pads on the mosses, seen clearly in the dampness, made during nightly visits to the sanctuary.

Climbing the bank I could look out across my garden to the red, white and pink blossoming heather. In complete contrast, the needles of the Colorado spruce (*Picea pungens Glauca*) are spiky and stick out stiffly like spines on a giant hedgehog. During April through to August the sanctuary is ablaze with wild flora. The bugle forms extensive carpets of intensely blue vertical flower spikes. Where we have coppiced the trees or formed a meadow, the bugle has always been one of the first plants to appear, rapidly colonizing much of the cleared ground. Butterflies and bees frequently visit this plant.

At the foot of an immense oak I discovered a sapling holly tree, a self-seeded plant, strong and sturdy. I transplanted it to the orchard where its berries would be appreciated by the birds. There are many plants that we introduced, but there are many we did not — where did they all come from? The stinking hellebore, toadflax, violets, wood anemones and vetches: they were not here when we came. The foxgloves grew profusely once we had opened up the woodland. I imagine that the other plants must have done the same.

In the orchard stands a *Cotoneaster hybridus Pendulous*. As its name implies, it cascades from a five-foot trunk and in June clothes itself with fragrant white hawthorn-like flowers, attracting bees and hoverflies. During the winter months, the birds feed on its orange-red berries. Of other varieties I planted Mojave, Orange glow and *C dammeri*. *Berberis thunbergia erecta* is

grown as a narrow hedge around an area of lawn. It has dark red foliage of remarkable brilliance and straw-coloured flowers, suffused with red.

Beneath this shrub is a *Juniper horizontalis Glauca* with slender sprays of blue-green needles, hugging the ground. Introducing these shrubs, nectar rich plants and planting the orchard has helped to convert the sanctuary into a rich gourmet habitat.

The Forestry Commission cleared parts of the wood. After the whine of chainsaws could be heard, trees that had stood for centuries crashed to the floor. The stands of trees were put up for sale and we were promised seasons of pleasure once the new trees were established. But to the concern of many naturalists and the local people, we discover that at least one-third of the area cleared was to be replanted with a quick cash crop of pines. The pines have long needle-like leaves growing from twiggy branches in clusters of two or more.

The devastation of the wood was upsetting as foresters moved in with cranes, trucks and chainsaws, creating unbelievable noise. There was a lot of speculation by the residents as to whether the land was being cleared for housing. After several weeks of total devastation our friend Bob (concerned with the protection of badgers) and I walked across the cleared areas to check a badger sett. To our dismay, it had been bulldozed despite Bob's effort to supply maps of the badger setts in the area to the landowners before the contractors moved in. The whole area had been razed to the ground, and where huge bonfires had been lit the undergrowth had gone with it. Bracken, brambles, young shrubs and sapling trees had all been reduced to ashes.

Saleable logs and tree trunks had been loaded onto a fleet of lorries and the unusable waste thrown onto the bonfire. During that period more deer were killed on the road than ever before. We were compensated to some extent by the birds that left the area to take refuge in the sanctuary.

We were not impressed by efforts to replant the cleared areas. A group of foresters drove their spades into the newly cleared woodland floor, tossed a tiny pine tree into each of the slits, then closed it with a firm tread. The foresters then adorned the young trees in little plastic jackets to protect them from the attention of the deer and rabbit populations. Those pines will do little for the environment and will cut out most of the light suppressing the formation of new undergrowth. I noticed that there were firebreaks between the rows. The dappled sunlight filtering through the trees would soon be forgotten. The darkness of the pines would bring a somber tone to the area. The wood anemones, sorrel, bracken and other plants would struggle to survive.

There is little food for sustenance in such a wood, as pine needles take a long time to decompose. However, before the pines grow too large, we should see an increase of bluebells and foxgloves in the newly cleared areas. But the newly planted trees are fast growing and the habitat will soon change. I recall standing deep in thought as a council hedge-trimmer tore the length of the lane, ripping through the hedgerow with its mechanical blades. No time was taken to reprieve the hawthorn and spindle it in order to provide winter berries for the wildlife.

Lichen, fungi and mammals live in the conifer wood: the firs spread their crinoline skirts so widely that there was no room for anything to grow. Only the mosses are abundant in the damp, shady atmosphere. On some of the dead trees, lichens grow in a variety of colours. The silvery-grey cups of one species and the yellow-orange of others make up for the absence of flowering plants. Tiny brown-winged moths, muntjak, roe and fallow deer, rooks, jays and shrews live in the wood, but there are no badger setts; they are in the sandy areas.

However, the hazels that had I dug up and transplanted in our grounds when the foresters were clearing the site became well established around the stream.

Part Two

A Year in the Life of a Sanctuary Gardener

Chapter 7
Harsh January

It seems to me that snow is forecast far more often than it actually falls. I always wait in eager anticipation for the first snow shower, for then I can more easily track the wild creatures. Night after night the weather forecaster got it wrong until I awoke one morning to a strange light. The whiteness contrasted beautifully with the red of the foxes. Travelling over the snow, they made their way nightly to the food and in the morning I could track them to the woods and find out where they holed up.

Icy fingers turned the heather foliage to fiery red. Encrusted with frost, the plants were transfigured. The snow-bound evenings were captivating and to add further beauty, the moon in its first quarter shone over the glen. The snow opened up unseen territory, lighting up the many places normally too dark to observe. I noticed from the tracks that several foxes had run cross the sanctuary and disappeared through a gap in the hedgerow.

A close look at the geography of the woodland revealed that many years ago the habitat was totally different. There were fewer trees and open heath land. One could only guess at what brought about the transformation; I surmised that the heath land was grazed upon years ago and ceasing to do so brought about the change.

The last of the light was dying as I sat staring out from a darkened room. I had decided to stay up in the hope of seeing which of the creatures came to dine on the food that I left out nightly. By twelve o'clock the only reward I had was the occasional glimpse of a muntjac deer, and from time to time I hear the sound of their harsh barking. The appearance of the deer served only to heighten my enthusiasm and I counted myself lucky that I saw any at all, for those wary creatures spend much of their day hidden in deep undergrowth.

As the snowflakes silently fell the food supply became covered. I had to risk the foxes fleeing from my scent, and crept out to gather up the food and replace it again on the surface of the snow.

I continued to watch until my eyes began to deceive me and I constantly saw movement where there was none. Then suddenly, there he was, standing in full view of the dim lights attached to the wall of the hotel. The handsome russet-red fox moved hesitantly towards the food only three feet away from me. Separated only by a sheet of glass, I could see him whereas he could neither see nor smell me.

The warm golden-brown of a vixen also caught my eye. The first fox was already aware of her presence and left the food to greet her. There was a lot of mouth licking before they indulged in a wild gamble on the lawn, chasing each other around the rhododendron bushes. I had never seen such energy: they careered through the rhododendrons until exhausted, when they both lay down on the grass to rest. The vixen was considerably smaller than the dog fox and her tail had a white flash that did not fully encircle it, but stopped half way, whereas the dog fox's brush was magnificent, long, thick and bushy. I saw an overlying layer of black hairs on an otherwise red tail, which was tipped with a bold flash of about six inches.

I was completely lost in the pleasure of observing the natural behaviour of animals in the wild, usually seen at their best when guests are asleep.

There was no discomfort entailed by the harsh weather: I was seated in a comfortable armchair in a cosy room.

For convenience I gave the foxes names. The dog fox was called Russ and the vixen One-Sided-Flash. The evening became night and I was reluctant to leave. No more foxes appeared, however, and when Russ and his vixen departed at two–thirty I finally went to bed.

The foxes became less alert and I frequently disturbed them when the urge to mate made them forget their suspiciousness of humans. One evening, I was listening to the owls calling. First the 'ke-kiewk' of a little owl echoed over the glen and not long after the soft 'whoo-hoo' of a tawny owl sent shivers up my spine. As I listened I could hear rustling and snapping of twigs. After a slight hesitation I detected three sharp barks followed by a peculiar gasping sound. The creature screamed and a vixen emerged from the bracken some distance away, pursued by a dog fox. The two always made their appearance from the southern side of the sanctuary. I hoped that I would be able to locate their earth should they produce cubs. In the background, I could hear the rasping cough of a roe deer and the bark of a mutjac. For people who aren't familiar with these noises of the night they can be quite alarming.

The foxes stayed for two hours until the sudden noise of a car door banging startled them. Heads raised, ears pricked, and the four pairs of black-stockinged legs trotted out of sight into the undergrowth.

In Stony Wood there are plenty of signs that the muntjac deer are in residence. I followed their V-tracks deep into the cover and counted eleven trees that had been stripped of their bark. Underfoot was sodden, making me glad of my walking boots and that I had waxed them well. As the night wore on, a feeling of wildness increased with each gust of wind. The deer barked incessantly, crashing about in the undergrowth causing birds to stir. There was a constant shifting of feet and strange murmurings. A rabbit gave a scream of terror as some creature caught it.

Above all this chaos, stars flashed from a frosty sky. Long dark shadows of the trees were cast over the area that I intended to watch, make observations very difficult.

Tony spotted my dilemma and brought a tungsten lamp on a stand: the extension lead was so long that I could place the lamp deep in the undergrowth, and thus conceal it from the foxes. The beam was fantastic: every leaf, twig and blade of grass could be seen clearly. It is advisable to use a red bulb, as this is more acceptable to the wildlife. The tape machine was also switched on to record the sounds of the night.

At eleven o'clock I placed the food — meat, bread and fruit — for the wildlife in the well-lit region. It was very late when I saw my first fox. The bright lights unsettled him for at least half an hour. I sat in my usual place to observe him through the French windows. As long as I stayed perfectly still, with the doors closed and the indoor lights switched off, the foxes would come. The fox in my view was a newcomer: a gorgeous red-tan with triangular velvet-brown pricked ears and a marvellous bushy tail. He was joined fifteen minutes later by a small vixen. She was unusually marked, a peculiar yellow-tan, and lacking the facial markings of a fox. Even stranger was the parting in her hair, running from the top of her head to her nose. She would be unmistakable, easy to recognise should she continue to seek out the food.

The heather was in full flower, and the bank took on a delightful hue so admired by the holidaymakers. The moonlight touched the white flowers softly and I noticed that the pale colour of the crocuses had become ghostly in the twilight. The snowdrops and crocuses peeped above the snow and soon the picture was complete as both Russ and his vixen arrived; I had not realised just how much snow had fallen until I saw that One-Sided-Flash was up to her knees in the stuff. I managed to take several photographs of the foxes and flowers, which I hoped would be good enough for me to paint from later. I doubted, however, if I could ever capture the beauty and the perfection of the composition before me.

Like Bracken, both the foxes seemed to enjoy the snowy conditions and spent a lot of their time gambling to and fro across the meadow. I watched them with intense pleasure.

Another night, the mothy vixen trotted into view just as I was about to lock up and go to bed. She was alone until the woodcutter's black cat arrived. The two registered a sort of recognition; the cat, walking slowly, tail lashing from side to side, was the first of the animals to seek possession of the food.

The next morning I saw a dead woodpigeon, a perfect specimen, lying at the kerbside. It must have been killed very recently as the wildlife had not yet discovered it. I decided to take it home for the foxes rather than leave it where it was. On my way back I met Tony and Bob. We set off together for a walk in order to check more of the badger setts. I had to run every few yards to keep up with their long strides. We branched right at Eeyore's Place, to avoid the boggy area containing many varieties of wetland plants. The honeysuckles had started into growth: tiny buds covered the stems. I clambered deep into the tangled vine and discovered an old nest, still beautiful. The fluffy white seed heads of the old man's beard (*Clematis vitalba*) growing nearby had been blown down in the wind and their soft material lined the nest as snugly and effectively as the birds feathers.

Winter colours of fawns and purples dominated. In sharp contrast, the common yew (*Taxus baccata*) was the darkest of green. Beneath the yew the lovely Beacon silver (*Lamium maculatum*) covered the ground. In spring, its intensely white leaves contrast superbly with the yew tree.

The day after brought a cold but exquisitely beautiful morning. Everything was glowing in a soft light. The trees had lost their substantial look to ethereal beauty, delicate carved ivory branches against a greyish sky. The wintry sun bathed the sanctuary in shades of apricot. Bracken ran out, eager to be off, shaking her feet as she trod on the frozen snow. The plants had all been transformed into topiary shapes: squat dwarf creatures and tall white pyramids stood side by side breaking up the uniform flatness that the previous days snow had created. The spectacularly long outstretched arms of a dwarf conifer radiating from a central boss and thick with snow resembled a giant octopus. The encrusted hedgerows were thick with strange flowers. The sharp leaves of the bamboos were tipped white, and the rusty old horseshoe that Michelle had nailed to a tree the previous summer held a crescent of snow, a luminous moon on the dark rugged bark of the oak. Guests stood enraptured.

The bitter weather continued. Russ and his vixen continued to visit the food supply and were joined by three other foxes. I decided that they were females because of their size, and the fact that Russ did not chase them away. I was able to sketch them using a torch, held in position by an old wire coat hanger above my sketchbook. The torch, covered with red paper, filtered the

light and gave me sufficient illumination without revealing my hideaway to the foxes outside.

The new tungsten lamp outdoors was bright enough for me to operate my video camera, but an extra pair of hands was needed to manage both the video camera and the Nikon. However, I made the useful discovery that the video camera fitted onto my camera tripod, and when screwed securely into position I could switch it on and off at will, leaving it to film once it had been focused onto the food.

The wild clematis spread whippy growth to embrace its neighbours on either side. The fluffy seed heads lost their silvery glow against the whiteness of the snow and looked positively grey. Each day brought a succession of new things, and an overwhelming desire to record them in my notes and drawings. In eager anticipation I would listen and wait and enter the daily events in my notebook. The entries overflowed and my writing became smaller and less legible as I endeavoured to record all the events as they occurred. I wanted to record the first flowers and the first wildlife and also weather conditions, the association of plants that pleased the eye and the wildlife attracted to them. My diary became more interesting not only for the annual comparison, but as a record of the seasons. Anyone who has kept a notebook will understand the thrill of looking back at some exciting event.

That first batch of snow disappeared, dull days followed moonless nights, and the strange snow-covered shapes that had stood in the sanctuary revealed themselves as conifers. The bun-shaped conifer was the last to loose its ermine cape. The snow slid from the tall slender Skyrocket (*Juniper virginiana*), which harboured at its foot the first snowdrops of the season. Their presence beneath the snow had been forgotten, their beautiful heads, like pendant pearl drops, barely supported by the fragile stems. There are double snowdrops also but they don't delight me as much as the simplicity of the single varieties. I also have a very old variety, name unknown, very classy with a green square on the lower section of the trumpet. The pure white petals were swept back, long and graceful. It wasn't long before a haunting silence prevailed over the sanctuary again; after three days of snow the thirty-foot *Junipers* looked majestic shimmering in winter glory once more.

There was a sudden hailstorm one afternoon, fast and furious. I walked to the three small ponds. The lower one, which is the smallest, was frozen solid enough to take my weight, but the deepest of them was not frozen in the centre. I could see pondweed already starting into new growth. Even in the bitter weather a water beetle sculled over the surface, and although I was blue with cold and my teeth were chattering, I found it hard to drag myself

away. I made my way silently through the sanctuary, not encountering a single animal. Climbing the slope from Eeyore's Place, I discovered the marshy area had frozen solid and I had to step from one grassy clump to another to avoid slipping on the icy patches hidden by the snow.

There were shrieks of delight from the guests' children. Their happy laughter and excited voices, talking of things they planned to do such as explore the woods, make snowmen, play snowballs and make slides, could be heard.

Some guests were down early for breakfast and they sat at a table at the window watching their children. Another guest was not long in joining us: tall and white with sightless eyes, a long mouth and a scarf around his neck. He seemed to be trying to peer from the garden through the windows. The BBC television weather report said that snow was not expected that night.

It is not always safe to listen to the forecaster, however. We woke up to another inch of snow. It was still falling heavily, thickening on the rhododendrons and transforming the landscape. In the car park the hotel guests scraped ice off their windscreens and ran their car engines, blowing black exhaust fumes into the atmosphere. Tony pulled back the tarpaulin from our vehicle as if to reassure himself that it was still there. The snow still fell, dark against the grey sky, white against the parked cars, and then the flakes were lost as they settled and mingled with the others. Several fat snowmen appeared in the meadow, outnumbering the guests. (Tony thought it a pity we couldn't charge them for bed and breakfast.)

There were days, too, when Hazel Copse, Brockmere, the Heath and the clearing were all hidden under a soft blanket of snow. In the clearing it lay smooth but the trees at Hazel Copse were mantled, drifts of snow lay blown in ridges like a ploughed field. I for one would miss the winter — there would be no skiing, no snowballs to throw for Bracken, no blizzards, no clean whiteness, and no tracks to follow. During the intensely cold weather vast flocks of redwings and fieldfares arrive to strip the holly of its berries. They start at the topmost branches, working their way down the tree. It is not merely luck that brings them; I have provided this habitat, and their presence is my reward. They spend much of their time chasing off the blackbirds, and squabbling among themselves. Beneath the holly where berries have been dropped, the smaller birds take advantage of the feast. Every now and then I take stock of the sanctuary plants and add a new berry where possible. The bird population appreciates the freely available bonanza.

The chalet that had been erected the previous October proved to be an ideal hide for photography. The owl uses the roof as a feeding station, swooping up to perch upon it, rodent trailing from his beak. Grey squirrels jump down

from the trees above and bounce energetically over the roof. Wood mice squeeze through gaps in the walls, finding it more comfortable than living outside, and at night the moths are drawn to the lights. People often say: 'It must be lovely to live here in the summer, but I am not sure that I would like to be in the country in the winter time — all those trees, it must be so dreary'. Dreary it is not for there are bright frosty days when every branch is clothed in ermine and crystal, every blade of grass sheathed, every leaf encrusted with rime and every conifer needle sharpened, transforming the sanctuary into a fairyland.

Tony and I inspected the young fruit trees that we'd planted the previous November. The cordon apple trees were fine against their solid wooden supports. We endeavoured to shake the snow away from the young standard trees, where the branches were so overloaded that they were likely to be broken or damaged by the weight. We looked forward to autumn, when we would enlarge the orchard and plant pears, plums and apples. The chosen fruit trees had already been ordered. The list included Mountain ash (*Sorbus aucuparia*) and Whitebeam (*Sorbus aria*), also Guelder rose and *Acer campestre* as extra trees for the wildlife.

After about half an hour's inspection we moved to the clearing and my field glasses picked up the shape of a muntjac deer. We watched him foraging among the fallen leaves. Beyond and above on the slopes a group of roe deer, alerted by our presence, were startled into flight. Following their leader, they rushed off into the wood, white tail patches conspicuous in the half-light. The muntjac seemed to have been unlucky; a number had been injured or killed in the lane bordering the sanctuary.

Yet another flurry of snow beset our little community. Still thinking like a naturalist, I wondered where the prints would lead. The thermometer registered 12 and a strange silence prevailed throughout the sanctuary. Snow was heaped on the window ledges, but when I opened a window and scooped up a large handful of it, I found it was too fluffy and dry to form a snowball.

Into the white world I padded before that fairyland vanished drip by drip, leaving my footprints next to those of the foxes. The orange-red globes of the Chinese lanterns (*Physalis franchetii*) hung like Halloween lamps in a double row on either side of the tracks made by the wood mice (identifiable by their tails). One plant had lost its outer casing and only the veins remained, revealing an intricate structure with a red berry peeping through. I took a single shot as I had the camera with me. High on the ridge I found the prints of foxes and badgers and the deep clefts of muntjac and roe deer.

The first bold tracks I found on that walk were those of Bracken, leading straight into the woods. They were crossed by the typical narrow track of a

fox. As I entered the woods I observed another set of prints running parallel to the ones I was following. Obviously a vixen had joined the dog fox in his hunting, for January is the mating season for those beautiful creatures. A large clear imprint of a bird's wing, where it had taken off in a hurry to avoid capture, could be seen in the snow. There was no sign of badger activity — they had stayed underground all night. I placed food on the ground between two of their setts and managed to restrain Bracken from eating it. She sat on her haunches, her breath a swirling mist in the freezing air. She nosed a berry clinging to the firethorn (*Pyracantha*) bush.

A group of coal tits failed to get a grip on the snow-covered branches. Marsh tits are also particularly fearless during a cold spell as well as willow tit, which can be distinguished from marsh tits by the extent of their black crowns and chin patches. The long-tailed-tit is insectivorous throughout the year (although they will come to the bird table) and normally stay together in flocks hunting the hedgerow and shrub walk.

Bracken's feet broke through the crusted snow and a stiff wind whipped over her fur, tugging at her ears. She stayed close to me, engrossed by the comical antics of a jay, surprised by the sudden barking of a deer. Deep in the woods, Bracken came across the remains of a rabbit. The head was missing so I presumed it to be the work of a fox.

When we finally reached the sanctuary again, Bracken barked at an intruder: a large fat faceless snowman wearing a woolly hat. I picked up a couple of acorns and pushed them into the round ball. Our snowman stood slant-eyed with a lecherous leer, making me glad I had not discovered him in the dark. Before going to bed I glanced out of the window. Blue shadows from the trees cast by the light from the hotel fell across the snow. The snowman looked sinister as if waiting for the dark before he dashed off into the wood. Behind him the pool was solid, like a huge glacier mint. The foxes did not appear.

The next morning silvered cobwebs festooned the umbellifers, resembling crystal chandeliers. Tony went to inspect the road in order to gauge driving conditions, as a number of guests had not arrived. The weather forecast described freezing conditions, making driving treacherous. Bracken gave a fine demonstration of Thumper: she ran round the corner at her usual pace, slid the last few feet on her side and landed in the ditch looking quite bewildered. She was not the only victim, however. Further along the road, a car failed to negotiate a corner and the driver lost control on the icy surface.

We walked up the lane where we met two police officers. They asked us about our badgers — had we seen anything suspicious? They also enquired about the hawk, having kept a wary eye open the previous year, when they received reports of a strange car parked in the area near the nest site in June.

Wearing skis for enjoyment, I set out to check the badger setts at Brockmere. Bracken, very excited at my elongated feet, barked and snapped at them hysterically until she tripped me up. I threw snowballs for her to catch. The sky darkened to a peculiar yellow light. Every bush and tree, every creature, seemed to be waiting. And then down come the flakes of snow, slowly at first, spiralling like wind-blown leaves. There was no wind, only silence and stunning views like a ski resort.

In that world of winter beauty a dark shape suddenly descended from the sky, a vision of pure energy, powerful feet outstretched and wing tips raised. The hawk brought down with him a woodpigeon. Feathers tight against the snow, he rose a few inches and banged the woodpigeon down repeatedly on the frozen surface. A deep gash ran across the bird's neck and shoulders and oozed blood where the softly feathered, needle sharp, talons had pierced the flesh. The wind blew the snow and soft grey feathers in a flurry, hiding the hawk momentarily from my view and covering the evidence on the ground. He turned the dying bird over and pulled feathers from the chest, probing into the flesh with his vicious beak.

After taking photographs I telephoned the Royal Society for the Protection of Birds to report the sighting. I was amazed, with the predator about, at how many small rodents ventured out in the hours of daylight. A large colony of voles had made their home beneath the rhododendrons. Sometimes I saw them leave their cover on a perilous adventure to the food compound, where all leftover food was deposited for the wildlife. Aware of the danger from above, the voles, bright-eyed and tight-bellied, scuttled along the path hidden by the shrubs, clinging close to the wall until they reached the safety of their homes.

Chapter 8
Unforgiving February

The icy hand of Jack Frost painted an artistic picture in the dead of night. Like the soft breast of an owl, intricate swirls and feathers lay embossed on the windowpane. I hesitated to rub away the ice and destroy its beauty, but I wanted to see outside.

The sun was trying to break through and its rays emerged through a gap in the clouds, striking the frosted branches of the sanctuary birches. I made a quick note of where the sun's rays fell and considered the view lines from every window. The camera recorded the details for me. In the winter, it is best to have flowering plants where they can be seen from indoors without the need to go outside. I intended to note where the sun fell at different times of the day throughout the year. It was six thirty am. I made Tony and myself a cup of coffee and turned on the radio. The forecaster was reporting heavy snowfalls, blocked roads and motorists forced to abandon their cars. Definitely weather for long-johns. The postman's van slid into the drive, a welcome sight. It's a marvel how he kept going, especially as we are perched on the top of a hill. Our road came to life — the motorway was blocked and traffic was diverted past the hotel. People blue with cold sought warmth and hot drinks. Although it meant an increase in trade, we were glad to see the road regain its quiet existence when the motorway was reopened.

A wintry walk took us to Brockmere to check the badger township. Bracken raced on ahead, disturbing all the wildlife with her boisterous antics. Despite the icy weather, it was cubbing time at the badger sett. It is a quiet

glen visited by roe and muntjac deer and the occasional forester. The outlying sett had been chosen by a young female, one of countless generations of badgers born among the grey craggy rocks. The age of the sett is unknown, but the woodcutters informed me that it had certainly been in existence for a long time.

The light and dark grey rocks were speckled with flakes of snow and from a distance look like squatting guinea fowl. The rocks and trees shield badgers from the winter gales.

The beginnings of new life were everywhere: large buds on the rhododendrons promised a grand show at the end of May. Soon the lords and ladies would be dancing in the woods — not true flowers but pale green and red-coloured spikes thrusting up to the sky. They are intriguing and strangely beautiful. Although the berries are poisonous to humans, the birds relish them with no ill-effects. I was thrilled to see that my camellia Lady Claire was in full bloom: fifteen fully open rose-pink flowers on a young two-year-old bush. I counted another seven fat buds showing a glimpse of colour. This was our only camellia, but after seeing its brave display I decided that I would definitely introduce more. They do best growing on a northwest wall, sheltered from the early morning sun. Sunlight on frosted branches turns flower buds brown and ruins the spectacular display. The irony is that frost stays all day in the sheltered pockets, and where you think that a sheltered place may provide warmth and protection it is often quite the opposite.

I walked to the hide at Eeyore's Place. This hide is merely a framework of branches covered by dead bracken. Its main support is an oak tree, which has a few conveniently placed branches on which to build the structure. Tony left an opening where we can enter and observe or film. I had just settled myself when a bird dived down. At that moment Bracken decided to make an untimely appearance and upset the bird's hunting. The hawk returned for a second strike, his barred chest clearly visible in the sunlight. I saw the rabbit before Bracken, as it sought to take its chance crossing the reserve. Bracken broke cover to play with this exciting creature (she never hurts the wildlife) as the hawk checked his flight long enough to allow the rabbit to scoot off into the sanctuary's shrub layer.

Overhead a nuthatch whistled his approval. I spotted his orange breast and conspicuous black eye stripe (which looks like eyeliner). The robin is probably the easiest bird to recognize. Our notion of him is reinforced each year at Christmas time with all the cards picturing him in the snow. The song of the robin rivals that of the melodious blackbird; he sings all year round. The red breast acts as a warning to other male robins and not as a courtship display to the female.

The aconites, a sheet of gold, are particularly lovely after a light rain followed by sunshine. The golden open-mouthed chalices surrounded by a lacy collar of green are exquisite. Each yellow cup on its lace doily had a small point of dew in it, which glittered in prismatic colours. They are the sunshine of that grey month. Among the aconites were yellow primroses: they had naturalised rapidly, with clumps coming up in the most unexpected places.

We have numerous species of hellebore. *Stinking hellebore*, a native plant, has pale green cups each with a red rim, above the dark leaves. The *Hellebore orientalis* has eye-catching maroon flowers with gold stamens and looks lovely with pure white snowdrops. The oriental hybrids come from Greece and Asia Minor – hence the name. The flowers are usually in shades of pink and sometimes heavily spotted. Last year I came across a rather lovely *Helleborus corsicus* and purchased a single plant. The leaves are hard and serrated at the edges like a saw blade. Whoever said that winter is dull should walk in our sanctuary!

Vivid blue stars of *Anemone atrocoerulea* nestled in the corner of the rockery. Next to those were dark blue crocuses. Looking along the line of the rockery — I had to blink twice — a clump of black and white crocuses had shot up. The unopened buds were actually dark purple, but from a short distance they appeared completely black. I was so entranced by the variety that I almost failed to see a similar group further along. They had opened to a

deep lilac, with three of their outer petals feathered deep purple on pale buff while the inner petals were a rich violet-mauve with orange anthers. I searched for my order form and discovered that they were a variety named Minimus and the others could possibly be the species Lady killer.

Sharing a bed near the chalet are two shrubs, a Dawn (*Viburnum bodnantense*), its pink flowers almost luminous against an indigo sky, and a Spectablis *Forsythia X Intermedia* that trails long arching sprays of golden-yellow in March. Unfortunately the birds were attracted to the forsythia and devastated it; I had to remind myself that I planted the sanctuary for wildlife. The bullfinches played havoc on the wild cherries and the ash trees in the orchard. The striking male is unmistakable with black cap and reddish under-parts; the white rump is very conspicuous when the bird is in flight. The trees and shrubs support a population of living things as I anticipated.

I thought that February would be a difficult month to write about, but I found many flowers hidden in the grass such as pale blue puschkinia and the electric blue of *Scilla sibirica*. I also came across the miniature Iris (*Reticulata*), a fragrant species. I spotted the lovely sky blue of Cantab and the red-purple of *JS Dijit*. Further along the grass bank was *Histroides major*, also a vibrant colour. There were also the newer varieties of Pauline, Clairette and Joyce. I have no particular preference for any individual variety: they are all exquisite. They grow in humus-rich soil along with hellebore, pulmonaria and early primroses.

Hazel Copse was beautiful, not so deep in shade as the birch grove, yet the copse has enough canopies to shelter birds and squirrels, voles and mice. I was hoping to encourage dormice to this area. Sitting quietly you could hear rustling and the squeaks of the many small creatures that abound. The copse is an industrious area, favoured by squirrels and mice for the tasty nuts they can find, but I wish that they would let the nuts ripen before destroying the harvest. Hazel has another use, as its wood makes wonderful walking sticks. Cottage workers cut the hazel to provide springles to fasten down thatch. We planned to coppice the hazel each year so the dormouse would find the copse to his liking. As I left Hazel Copse, a shadow was flung across the meadow, and a sparrow hawk landed on a branch of a wild damson tree in the orchard. Once he had secured a grip he folded his wings and looked fiercely around. As I did not wish to disturb him, I backed slowly away after taking a photograph with our new camera.

The gardeners' garters had turned from straw-like wands into blue-green swords. Shining like sharpened steel they surround the lower edge of the pool. Look round at the landscape I could not help but feel satisfied with my efforts.

Each morning I read the snow like the pages of a book, it told me of the nightly wanderings of our wildlife. I entered the results in my diary, for example: "18th February. Tracks of a stoat, stonewall near ponds."

Stony Wood foxes had had a busy time: their prints were everywhere, criss-crossed by those of a badger. I followed the badger prints to Brockmere but they petered out in the denser part of the woodland where the snow could not penetrate. There was no sign of animals, but the jay cackled at me from his slippery perch. I watched as his identical twin made a crash-landing onto a branch nearby. He gave a raucous call, signalling danger to the other inhabitants, before flying off. I took the path made by the fox on his nightly travels and found myself walking parallel to the stream which, in the intense cold, seemed to have lost its rhythm and was partially frozen. Ice had formed along its banks and only a narrow trickle of water was visible. Nevertheless, a vole scampered across to his home in the bank.

The cattle at Hill Farm, rear ends to the wind, munched softly on the hay, their breath hanging thick on the cold air. The farm keeps a strange assortment of bullocks: Charolaise; Friesian; Jersey; Hereford and the smoky grey Blue Albion from Derbyshire.

Overhead a wedge of wild duck, grey on grey, winged its way noisily towards the icy river, reminding me of a painting I have by Peter Scott. It is signed 'Teal on a grey morning'.

As I walked through the sanctuary looking for signs of wildlife, I discovered a small bird that had not made it through the night, lying prostrate on the ground. I wandered with Bracken through the shrub walk, entering the orchard and then Bluebell wood.

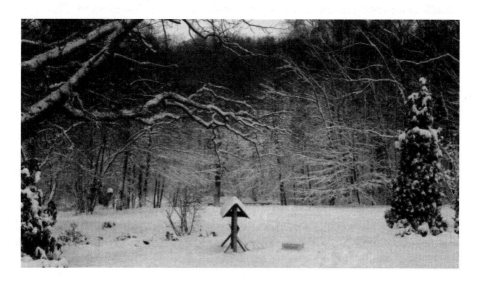

On the way, I noticed a beautiful mistle thrush. I was staring at his speckled breast when a blackbird scolding loudly exploded from the firethorn bush like a bullet out of a gun. When I returned to the hotel I found that Tony had made me a bird table and I placed my hide — a green sheet with provision to take a camera lens in all sides —closer to the site. However, I wish my photographs to seem as natural as possible and I introduced a branch as a perch nearby, so that the birds waiting their turn to feed on the nuts would to use it. It was a bit flimsy and any creature larger than a chaffinch tended to spin it round into a different position. I contrived to get the branch into a more suitable position near a framework of snow-covered shrubs on which I tied artificial holly berries left over from the Christmas festivities. My plan was to entice the redwings and fieldfares, which become bolder and lose much of their fear of humans in the harsh conditions.

Six weeks into the New Year and the temperature was above freezing as the snow began to melt in patches. With the thaw came the rain. Patches of lawn disappeared again, but under large areas of water that time. The new pond turned muddy with silt, obscuring the growth of the water lilies. Crocuses drooped sodden and bedraggled. We walked to Hazel Copse and found our way barred by a silken thread strung with drops of water.

The blackthorn, or sloe (*Prunus spinosa*), had started to blossom in the orchard. When covered in flowers it attracts every bee and insect in the neighbourhood. The colour of the bark is blackish and the ends of the branches sharp with vicious thorns. When the blackthorn is in flower and the weather is cold then the season is called a blackthorn winter. The dense tangle of thorny twigs make the shrub a much sought after nest site. Chaffinch, dunnock and greenfinch favour the blackthorn and the hawthorn to any other shrub. It may seem rather foolish to have added a species to the sanctuary that is already common along our lane and hedgerow, but my reason for doing so was to encourage a larger selection of butterflies and birds to the sanctuary. The tough and hardy hawthorn can withstand hard pruning and those planted closest to the hotel will be kept at a manageable height. The hawthorn at the sanctuary boundary does not flower until May. In the autumn, the well-known red haws follow the flowers. I've known since I was a child that both the haws and the leaves of this bush are edible.

One night, we were awoken to the sound of loud gunshots and the breaking of twigs, accompanied by the barking of deer. The noise came from the direction of Hazel Copse, but gradually moved closer until a barking deer was standing on the lawn by our bedroom window. Tony and I listened intently. Suddenly, a shadowy shape moved along the boundary: it stopped and stood still until summoned by a blast on a car horn. Bracken kept as quiet as we did. She was unmoved by the poachers presence.

The following day, I saw Russ up on the ridge above the glen. He was on his own, but by the time I had reached the glen a small vixen had joined him. I was surprised to find that it was not One-Sided-Flash. Through the field glasses I had a good view of the pair, moving off towards Brockmere, running side by side. I took the badger path, tiny nettles showing green on either side of the track. Bracken bounced along upsetting the wildlife long before I noticed and called her to heel. I made my way to the barbed-wire fence and slipped beneath.

After spending just ten minutes at Brockmere I moved to investigate the badger sett near Hazel copse; I had to be quick as I was cooking breakfast for our guests. It was snowing again but not settling. The hood of my duffle coat gathered the flakes. When I pulled the hood up over my head some of the flakes found their icy way down my neck. I walked to the glen, surrounded by unseen songsters. A jay flew across my path and descended to the woodland floor in search of something edible, annoying the two handsome grey squirrels that were busy trying to locate the acorns that they had previously buried.

A quick look around the badger sett proved that nothing had ventured out: all the entrances were still blocked. Three badgers were in residence there, and they all visited the outlying setts regularly. Flocks of tits were perched on a wire fence, their voices silent. A piece of mistletoe growing on a tree intrigued me. The pure white berries shone: a pity I hadn't found them in time for Christmas. Casting around the Hazel Copse sett, I discovered no fewer than three new entrances. A fox occupied one, as the strong smell exuding from it revealed. Most of the badger setts were donkey's years old and enormous, having been enlarged over the years by generations of badgers. I made a mental note to watch the fox earth in case One-Sided-Flash used it as a nursery for her young.

The next morning a great spotted woodpecker was the first creature about, flying down to a rotten tree stump where he searched for grubs. His bright crimson head and patch beneath his tail complimented beautifully his black-and-white livery. The stump was riddled with holes and he enlarged them in his attempt to find breakfast.

Nothing was as it should have been that morning. The milkman had forgotten us and even the blue tit seemed cross — his usual peep-peeping sounds troubled. David telephoned the dairy to enquire where the milk was. Within minutes the delivery arrived. 'That was quick', I remarked. It was not until later when we received a second delivery, bringing our total stock of milk up to twenty-four pints, that we realised what had happened. The first delivery was our original order and the telephone call had resulted in it being duplicated. As I went to pick up the bottles I hear the pee-pee alarm call of a group of tits attacking the milk trying to extract the cream. The foil tops had been torn from their anchorage. Hanging upside down like circus clowns they

balanced with wings fluttering, blue heads, green backs and yellow breasts reflected in the bottles.

The new bird table was a great success in that the fat appealed to the great spotted woodpecker and I had no difficulty in getting a close-up photograph of him. I moved the bird table to a more open position, as the birds were using the natural shrub layer (which is in poor light) as perching spots. A nuthatch flew in to investigate the potential food supply and I took a shot of him balanced on a snow-covered log. A scene like that gave me a chance at some exciting action photography.

Later that evening, a lichened oak provided protection against an icy wind as I gazed at the sleeping countryside. My hide was unusable as the zip froze and refused to move. I could see a fox silhouetted; a dark shape against the sky. A thrill ran through me as she lifted her head and screamed. When I took a step forward, the vixen, alerted by my movement, melted into the shadows. There is great satisfaction to be derived from the study of wildlife in such conditions, everything seems sharpened — outlines, noises, senses. I concealed myself behind a tree and waited. After ten minutes, a fox passed within a few feet of my cover. He had an enormous duck in his jaws. I wondered which of the three farms he had visited. Blackness surrounded us, as the moon was lost behind the clouds. I call Bracken to heel and we walked back along the well-trodden badger paths.

Chapter 9
March Winds

The month opened with a cold fierce wind, blowing the leaves that lay thick in the sheltered places. Branches of the trees arched and snapped back against each other as though engaged in battle. The strong winds caused them to moan as they lashed to and fro, bending them like bows ready to release their arrows. The *Viburnum rhytidophyllum* glowed silver, its leaves reversed by the wind.

Many of the trees had realized it was spring. Although their branches looked as bare as they did in January, they were not as lifeless as they appeared. Sap was rising to the very tips of the branches, and tiny burgeoning buds were about to burst open. Hazel Copse had already heralded the spring. Masses of furry catkins, stiff and brown, swung merrily on leafless branches. The alders would follow the hazel a little later, but our oaks would not be hurried — they refuse to open their buds until May. I pulled a few twigs from the tall bush, and was showered in gold. Indoors I found a tall green vase in which to place the twigs. Even after the lamb's tails have fallen off, the buds would break into fresh green strawberry-shaped leaves.

Beneath the outstretched arms of the trees the marbled foliage of *Cyclamen coum* covered the ground. This is a cyclamen *par excellence* whose magenta-pink flowers are fatter than those of *Cyclamen hederifolium,* which flower in autumn. There are so many variants with silvered foliage embossed green, pale green foliage with large blotches of grey and dull bottle-green foliage with paler green markings. Day by day more flowers appeared, bursting

free of the ground that had held them captive for so long. The Dutch crocuses flourished, interspersed among the then-withering snowdrops. There was no longer an absence of movement; a bee flitted from flower to flower drinking from the chalices. I recorded the flowers on camera and made a note in my diary. One bee *Bombus lucorum* had difficulty taking off from a crocus cup, the pollen bags on her back legs so full, her flight appeared like a drunken stagger.

March weather is usually fickle. A misguided red admiral butterfly had awoken from its winter sleep to feed on the early flowers. Strangely, she was taking nectar from the snowdrops. I ran indoors for my camera, worried that if I didn't record it no one would believe me. Bracken, intrigued, stalked it. Following its erratic flight, she gambolled along mimicking the butterfly's dancing flight into a clump of young nettles.

We thought that we had seen the last of the bad weather but strong winds brought down the telegraph wires in the lane. Several large boughs, torn off the trees, lay splintered. Out in the pasture the farmer had a flock of Jacob's sheep, spotted like dominoes. There was no number ten, although I counted them all. The Friesians in the field below stood dejectedly, heads hung low. Perhaps they found it difficult to graze when the ground was so hard. The soil around the galvanized water container, frozen, bore imprints of the cow's feet. I saw underfoot the preserved slots of several deer and realized that they must have foraged through most of the sanctuary.

Suddenly I saw one of them leap from cover to cover, disappearing at length into the depths of the woods. It was good to know that they were using the sanctuary but we were not happy at the destruction they caused. The muntjac is one of the most difficult deer to track; wary and cautious, it avoids man completely. These small deer are more difficult to observe than roe as they are nocturnal. I could see where they had eaten: the heather had undergone yet another feckless pruning. The strong winds had caused the deer to seek shelter. I came across a doe, heavily pregnant but in splendid condition.

A herd of deer were attracted to our lawn towards dusk one evening. They barked continually for two hours just outside the hotel windows. They had been released earlier in the week by a local college and were declaring their territory. The disturbance in the undergrowth betrayed their presence and disturbed the roosting woodpigeons who took off in alarm with a loud flap of their wings. We advertise the hotel as being quiet and peaceful — that evening we could have been summoned under the Trade Descriptions Act.

There were signs that spring was swiftly approaching as restless birds flitted aimlessly from tree to tree. The wrens investigated the woodpile and a blue tit examined the boxes on the larch lap fencing for a suitable nest site. A male blue tit inspected a hole in the oak tree, as well as a box on the willow where a pair of coal tits had nested the previous year. As a surveyor, he was bound to pass my homemade boxes over. I counted the nest boxes in the sanctuary; there were twenty-six of them including eleven bat boxes.

Every time we wandered through the sanctuary we saw yet another flower that had blossomed for the first time. We found a group of *Dog's mercury* in full bloom. The daffodils were previously green-tinged sheaths but in March their heads were bent demurely allowing a glimpse of their lovely colour. I had planted ten thousand during the previous autumn, but I preferred our native wild daffodils with their pale perianths. They fit in better with the woodland garden. Perfect miniatures grew with wild abandon on our small rockery, sulphur-yellow trumpets enamelled with pale lemon. The variety Charity was perfect in form. We also had the lovely white dovewings and the multiflowered *Narcissus cheerfulness.*

From the cardboard box delivered by the postman would come a variety of new things: bistort and birdsfoot trefoil, meadow cranesbill, knapweed, ox-eyed daisy and many other wildflowers I had long since had the enjoyment of selecting. I had leisurely browsed through the catalogue, choosing plants to flower in the summer, and I could hardly wait to open the parcel.

Having encouraged the wildlife to visit the garden, I felt a responsibility towards housing and feeding some of the creatures throughout the year. While replenishing the bird table, I noticed that it needed some repairs. Tony was already occupied making more nest boxes, however. He was drilling holes one inch across and one inch deep in a log that would be nailed onto a post. I collected some hard bracket fungus from the sanctuary and fastened it to the post for the birds to use as perches. The holes were filled with fat, and were not long in being discovered. The great spotted woodpecker showed his appreciation by returning time after time. The log could also be suspended by a hook and chain from a tree. That particular attraction proved to be the most successful of all our feeders.

Well protected against the weather, I sat in a remote spot in the sanctuary where I hoped to see the hawk. I followed a tapping sound, moving imperceptibly to avoid disturbing the carpenter who was laboriously sending out splinters of wood. The woodpecker was hard at work for his dinner. Our dead and decaying trees house the grubs of the wood-boring beetle. When he found a likely spot he held firmly to the trunk with his sharp claws, and pressed his tail feathers against the bark for extra stability while he extracted the beetle.

On the same tree, a tree creeper probed the trunk for insects and grubs. It zigzagged its way up the tree and pushed its slender beak into the crannies of the bark. Then it dropped down to the base of the trunk to repeat the entire procedure all over again. The nuthatch has a different approach. Defying the laws of gravity, he can not only encircle the tree but his toes are adapted to maintain a hold when descending headfirst.

Bracken dozed but was alert to the sounds. When a new noise aroused her, she lifted her head with interest. This upset a jay, and bright blue wing-flashes could be seen as he flew screaming into the trees beyond. Some of the birds were already in pairs. They flapped their wings in eager anticipation of the spring. It is this ritual activity that makes March so unique. The birds looked with renewed interest at the assortment of bird boxes fastened to the trees and fences. A pair of bluetits were very interested in a box lodged in a rhododendron bush.

Tony and I drove to a hotel situated by the river Thames. The chestnut head of a pochard caught our attention. Swimming alongside was a pair of great crested grebes: the male postured and displayed to the female, with his head outstretched on the water. I noticed how low these slightly built birds swim. They had several skirmishes with the coots that continually annoyed them. Graceful swans glided serenely, dipping their heads as if to survey their mirrored beauty and when a dog barked at them the cob raised his wings like a pair of sails, propelling himself through the river at speed. Blue-winged mallards added to the colourful scene. The air was full of the sound of water as it splashed from the weir. Two moorhens hugged the bank, attracted by the bread thrown into the water by some children. Then one of those rare moments occurred: with long legs trailing, a heron alighted on the far bank. He slowly folded his large grey wings about him like an old lady with a cape. The magpies pestered the smaller birds on the bank. Handsome in their black and white plumage, they foraged in the undergrowth with their strong black beaks, wary only of the hawk. When the hawk appeared they gave a comical sideways hop and flew up into the trees with a great deal of noisy chatter. Typical of their kind, they poured abuse down upon Bracken from above.

On our return journey a flock of gorgeous plovers (lapwing or pewit) settled on the fields. They are the commonest of inland plovers, easily recognized by their black crest and upper body shining green in the sunlight. The bird has a white belly with chestnut tail coverts, a black bib and white cheeks. It was the sound of their throbbing wings that drew my attention to them.

At five-thirty am the hawk heralded the dawn. This majestic bird of the sky is a true aristocrat, a blend of savage power and beauty. Soaring on the wing, head bent, he is lord of all he surveys. On a bitter cold morning I was out hoping to obtain some more photographs. I had barely reached the cover of the firs when I heard the cry of a buzzard, a high-pitched 'Mew-mew', and saw him wheeling in circles above me. He stopped circling to visit the farm, his favourite haunt down in the valley. The birds came to the bird table quite early that morning. There was no bickering that day; they were all subdued. They were thankful that they had survived the night and that their breakfast was ready.

The Stinking hellebore (*Hellebore foetidus*) seem to last forever. It gets its name from its slightly acrid smell when cut. The golden crocuses made the yellow primroses seem pale the previous year, but a new variety with soft lemon cups striped with brown had been planted in front of them and the association is a happy one.

The wild cherries were showing buds. A male bullfinch had noticed the development and stretched up his neck to delicately pluck a bud before it had time to open or be pollinated by the bees. He then reached down to pick another from the branch below.

Beneath the trees a decaying log, left where it had fallen, revealed hidden life. When I turned it over I found that its rotting underside was filled with debris. I found plant life in abundance: several mosses and lichens and a strange series of knobs, which I studied with my lens. They turned out to be the sprouting anthers of stag horn fungus. Among the network of spider webs were many species of creepy crawlies: a black shiny centipede coiled up like a whirl of liquorice, several woodlice, and tiny insects too small to be identified by naked eye.

I set off to look for wood sorrel, deep in the woods. It was a slow process. It was rare that I travelled more than a few paces without pausing to examine a plant or insect. In the crevice of a log I found a sombre-looking toad, cold and spongy to the touch.

The weather became so mild, the temperature reached 66° Fahrenheit, that the primroses became a golden carpet over the dell and framed the edge of the low stonewall of the shrubbery. When we first came here, there were no primroses in our garden, but they had invaded all the gaps in no time.

Two brimstone butterflies fluttered along the hedgerow, both males, coloured bright yellow. I entered the date in my notebook. I would have missed the tiny black-and-white bird, a lesser-spotted woodpecker, had I been on the move. In fact, he flew so close to me that I could have reached

out and touched him. My eyes followed him as he circled the trunk of a tree in search of hidden goodies. There seemed to be an abundance of suitable food as he was active for a considerable time. Fifteen minutes later I heard a tapping sound like a thrush hammering on a snail but the noise came from above. To my surprise, I saw the lesser-spotted woodpecker attacking a marble gall, trying to extract the grub within.

The birds responded to the increased daylight A fieldfare perched in the holly tree was joined by two more. Those splendid thrushes spend each winter with us and only when flocks gather to move on do we know that spring is on the way.

A letter arrived from the Royal Society for the Protection of Birds. A bird of prey that I had photographed had been identified as a goshawk. As the bird is a protected species, one of the rarest of birds to be seen in this area, the writer of the letter asked if he could visit. What amazing luck. The book stated that there are only nineteen pairs in Britain.

The postman also delivered the hotel accounts for the year. Tony was glad that it was not his temperature chart: the takings went up at an alarming angle, very healthy indeed! Naturally the accountant's fee matched the increase in takings.

The initial phase of work on the sanctuary was complete. I was fascinated by the abundance of plant life and had to rely on my field guide for assistance with identification. There are ivy leaved toadflax, shining navelwort and meadow cranesbill. Scattered plants of herb robert promised a rich colour when the foliage turned a startling red.

We have a multitude of rhododendrons from Nepal and Tibet. The variety Christmas cheer comes from Turkey. We also have the King George (*Loderi*), with a gorgeous statuesque habit. There are many other plants worthy of note, in particular *Skimmia japonica*, a shrub from Japan. It has red buds that last for weeks before opening into aromatic pastel-pink flowers that last equally as long, a superb plant for the sanctuary. In winter the female plant bears red-globular fruits. I walked around the sanctuary noting all the plants and writing down the names of others that I wished to acquire. I sometimes feel like I am walking around the world in one day, so vast and numerous are the plants and the countries of their origin.

The mood swings of the weather, from winter snow and brilliant light to damp and frost, did not deter the plants. Covering a flattish rock was a minute plant, *Frankenia thyifolia,* a superb little carpeter with pale pink flowers. Next to this was the fleshy steel-grey Casablanca (*Sedum*). Through this carpet the fat buds of the alpine tulip clusianna pushed their way up towards the light. I was amazed at how well the pulsatillas did in the peat

border, for those lovely plants are native to chalk. One plant of great beauty was our *Erythronium*, this lovely delicate yellow plant is a shade lover and ideal for woodland conditions. The structure is so beautiful in that the flower opens up wide from a pointed roof with the lower parts of the petals tipped backwards towards it. The name of this variety is very apt; it is called Pagoda.

The rooks made unlimited attempts to reach the wood on the other side of the road. As soon as they gained a certain height they were hurled back again, fluttering in the wind like fallen leaves. After numerous endeavours some of them actually made it but the remainder decided to stay where they were, rather than risk injury.

A commotion among the trees encouraged me to look up. A busy squirrel was building a drey. It was a substantial affair made of twigs, leaves and moss and was placed high in the fork of a tree above my head. The squirrel was most annoyed when he spotted me watching him, and stopped working to scold me and flick his grey and white tail angrily.

There was so much to discover in the sanctuary. I heard a rustling noise in the fallen leaves that still lay about the garden. Was it a mouse or a wren? Or maybe even a grass snake. I waited until a fat hedgehog waddled out. By ten–thirty the weather had changed. I clambered stiffly from my hide, numb from toes to ears. My lips were blue and I was shivering despite my new feather-down ski jacket. I walked from the depths of the woods to the hotel beneath the first stars of the evening. My teeth were chattering and I tried vainly to stop them. Suddenly, without warning, a white shape sailed past like a huge moth. The barn owl, about to start his hunting, floated eight feet above the ground, silent as a snowflake, his soft silky-feathered wings making not the slightest whisper and his blunt head held down, dark luminous eyes searching the ground for the slightest movement. The owl gave vent to an unearthly screech, terrifying the small vole foraging in the woods as he dived beneath a log.

The muntjac and roe deer were used to seeing Bracken and me and just gazed at us from a distance. If we came upon them suddenly, they never seemed to panic, but just glided off into the nearest cover. At a safe distance they usually pause and take stock of the situation. Those are the best times to take photographs. Outlined in the moonlight, the animals are silhouetted darkly, and look princelier than ever. As the clouds moved across the moon, blackness surrounded us. I called Bracken to heel and we travelled back along the well-trodden badger paths.

The bare trees covered with hoar frost glistened in the meadow, and the grass cracked noisily beneath my feet as I walked through the woods. Parties of long-tailed tits — tiny bodies like pink powder puffs — swept

through the trees, calling as they went, alighting simultaneously among the hawthorns. There was a crackle of icy leaves in the hedgerow and a sharp pointed face with two black teardrops peered at me. Suddenly the mask disappeared and the fox had gone.

One evening, wild with hail, I braved the elements to check on four of the badger setts: Brockmere, Hazel Copse, The Ridge and Badger Lane. The badgers had not yet left their homes. I leant against the solid comfort of an oak and waited, knowing that shortly a fox would come into view drawn by the smell of the chicken carcass ten feet away. The hailstones stung my face, and the hail eventually gave way to snow.

A noise to my right caught my attention. I picked out a faint movement and, peering through the flakes, I could make out the outline of a deer. The red-brown coat was heavily spotted with white: not a fallow deer but a snow-flaked roe deer. I waited patiently as she moved closer, stopping now and then to nibble at the shrubs. I had my camera with me but no flash. It was sitting useless on the counterpane of my bed, left there from when I changed the lens. I stood entranced by the wild creature of the night. Sights like that can only be observed in complete quietness.

I reached the sanctuary of the stable. There was no horse to welcome me, only the woodcutter's black cat who greeted me with a sharp cry. She rubbed herself against my cold legs. The powdered snow easily filtered through, driven by a stiff wind, as the stable door was slightly ajar. Cats are not encouraged in the sanctuary; every effort is made to ensure that it remains

a safe haven. Thirty minutes later I decided to return to the hotel. It was a wrench to go back outside, the blizzard was still raging and in the colourless light everything merged as one. The footprints that I had made earlier were already covered by fresh snow. In less than a month, the first fox cub would be born. With that depth of snow the foxes would find it hard to catch mice and voles, for those creatures burrow beneath the snow layer, well protected from the predators of the night.

The sky was beginning to lose its dark look as the night gave way to morning. When I glanced at my watch the time was six-forty am. A bird, perched on a low branch, was singing, his fawn breast becoming more distinctive as the light intensified. For such a tiny bird the wren's song is way out of proportion.

The badgers had gone to earth but the foxes were still patrolling the woodlands. I got a glimpse of Russ hunting along the hedgerow. He didn't see me and as I watched as something attracted his attention. A quick pounce and he stood eating his reward. When he left I could see the tail of a woodmouse lying on the ground.

I noticed a marvellous blood-red fungus growing on the trunk of an oak tree. On closer inspection I found that the upper surface was rough and the pores pale flesh-pink. I remembered seeing this variety, beefsteak fungus, at the end of November. When I dug my nails into its flesh it yielded a reddish juice, hoping it didn't stain. The beefsteak fungus is supposed to be edible when young but I was too nervous to try it. I took a single photograph of its stunning colour.

The larches were bare - they are the only British pine to lose all their foliage in the autumn. Most conifers are evergreen, but the larch is the exception. Its needles turn a soft yellow before descending to the floor. The larch boletus, a fungus with sticky honey-coloured caps, has established a link with this tree. The needles made a soft carpet for my feet as I returned home along the narrow lane. March came in like a lion, but at the end of the month the temperature was 70° Fahrenheit. There is a saying: in like a lion, out like a lamb.

Chapter 10
April Showers

It had to be an April Fool: our extensive plans for the hotel had been passed! The first set of plans was rejected for being too large, and we had been advised to submit a smaller plan. In frustration, we simply sent back a larger version of what we had originally drawn. Unbelievably, they were accepted.

Our first thoughts were, however, that unfortunately we would be unable to build, as the estimate was for over £100,000. Nevertheless, we immediately telephoned our bank manager. He was not happy and said he could not advance any more money. We replied, 'We can't advance without it'. We won the argument and received the loan, but not without concern.

I knew it was going to be a fine day. One by one the forgotten sounds of spring returned: the musical sound of running water and the dawn chorus. A breeze softly rustled the new spring leaves. The plants on the sanctuary floor took advantage of the sunshine before the canopy of leaves blocked out the light. There had been a gradual warming up of the soil and the plants were leafing up fast. After long weeks of continuous frost and snow, there was little now to hinder progress in the sanctuary. Getting into your garden early can reap rewards later and benefit the wildlife for the rest of the year.

In the meadow the ground ivy had flung itself in wild abandon across the earth and was in full flower whilst on the bank above, the first of the blue speedwell's small dark flowers could be seen. Other plants showing their leaves were the cuckoopint, garlic mustard, wood anemone and sorrel. The very first dog violet came into flower as early as April 3rd in the midst of snow and ice.

It is impossible to garden and remain unaware of the fauna all around. There was evidence of deer browsing in our small orchard. Their favourite food is the shoots of young trees. Much as I appreciate their presence here, they create havoc. They nibble at the new shoots as they appear and strip the bark off the young trees. Only their beauty prevents me from shooing them away. The wild cherries that line the meadow were white with blossom; the bullfinches and siskins in noisy parties were flitting from one tree to another. The siskins are colourful birds with a fine pointed bill that is designed to extract seed from the various cones of the pine, larch and spruce.

The goshawks are elusive and although I made an effort to locate them it was in vain. They both hunt in Stony Wood although there is no shortage of food in the sanctuary. We were aware of their preference for woodpigeons.

Bracken got very plump, like a chrysalis ready to burst its skin. I shooed her off into the garden but, unlike the foxes, she would not exercise herself. Whenever I stood still she came and sat at my feet, gazing at me with huge liquid eyes. I felt guilty as I shoved her away. Tony was engrossed by the book *Into The Heart of Borneo* as his relatives are part of the Brooke family, the *White rajahs*. We were very interested to find that a butterfly, huge, yellow and with transparent wings, was named Brooke's butterfly after one of the family.

By the stream where the ground was soft, I discovered a flower crowned with eight four-petalled blooms of delicate lilac. The lovely lilac-tinted flower has several names: milkmaids, Lady's smock and cuckooflower. I had planted the seeds to encourage the orange tip butterflies whose eggs are laid on this plant. A single egg was found just beneath the flower bud.

A movement caught my eye and I recoiled as a grass snake raised his head. He was curled up on the path, basking in the sun. Unaware that I had nearly stepped on him he slithered off into the woods to hunt his prey. In the sanctuary we are lucky enough (though some may disagree) to have adders, grass snakes and slow worms in the marshy area at Eeyore's Place. The slow worm (unlike the grass snake which lays its eggs in the compost heap) gives birth to live young.

One-Sided-Flash appeared alone one evening: she looked rather nervous as she darted in to grab food, and quickly rushed off again. At a quarter past ten a dog fox appeared for an instant. I wondered which vixen and cubs he was feeding. As I tried to adjust the flash equipment on my camera, a difficult job in the half-light, the dog fox returned. This time he did not withdraw, but stayed, interested in the bag of peanuts suspended from the bird table. He flattened my tulips as he stood on his hind legs in order to obtain the nuts.

He would not leave until he had his sooty forepaws on the upright post, causing the table to collapse with a loud crash. By then, my tulips were beyond redemption, lying broken and trampled in the grass.

Russ was dead, hit by a car. Even in death he was still beautiful, although the red-tan coat had lost its vitality and the colours lacked lustre. I felt very sad.

That night, the vixen made repeated journeys, and carried off food in different directions. I observed her for two hours when she made twenty-one journeys in total. I could only assume, from the short length of time between her visits to collect food, that she had her cubs hidden nearby. I would soon be able to observe them above the ground on fine days. The very first time that I saw newly born cubs I gazed at them in wonder; they didn't look at all like foxes. They are born almost black.

The next morning, one of our guests, whom we nicknamed 'Mossy Hughes' because of his interest in the mosses, lichen and fungi that grow on our land (he is a regular customer, I may add), informed me that a dead fox lay in the ditch near Whistler's Lane. I went to investigate.

Mossy Hughes spent a whole day listing the many mosses and lichens growing in the sanctuary. He determined that we have 56 species in our four-acre plot: an excellent count. To put this into perspective, the surrounding woodland has 200 species. Berkshire and Oxfordshire have about 400, and the whole of the British Isles has about 1000 species.

On my way through the sanctuary with Bracken one day I stumbled on a group of Solomon's Seal (*Polygonatum*), growing strongly in their woodland cover. Their pendent bells on tall stems lean in graceful arches like large lily of the valley, exquisite in this dark damp corner. I had long forgotten that I had planted them in the copse some time ago. In the clearing, the chiff-chaff had arrived: I could hear him calling. The tree pipit also arrives in April, and I eagerly awaited his appearance.

The previous two months had brought a succession of unrivalled beauty as the sanctuary yielded wood anemones. There were also several species of crocus including: Tomasinianus, a pretty sapphire-lavender; snowbunting (as white as it sounds) with masses of flowers delicately feathered in blue; Acryrensis, which flowers very early in February producing bunches of orange-yellow blossom; and Firefly, a wonderful vivid lilac-pink with orange stamens. I was astonished at the enormity of what I had created. The primroses and violets were particularly abundant, although their perfume was overpowered by the smell of the wild garlic.

I could see a multitude of bees around the primroses, including a small brown bee without any distinctive coloured bands. The carder bee is common throughout Britain. As I watched, I noticed a stranger in their midst. It was less hairy than the others and slightly larger. It was the cuckoo bee, banded in black and orange, looking like a member of a rugby team. The orange belted bee (*Bombus lucorum*) is much larger. She has a white bottom, whereas *Bombus lapidarous* has a furry red one.

The heathers had changed their colour, so that from a distance they appeared to be scarlet. They were covered in orange-red ladybirds sunning themselves. A bluetit cocked his head to one side, and surveyed me with as much interest as I myself showed in the heathers. As we returned home from our walk we halted to observe the familiar behaviour of a male blackbird in defence of his territory. He lowered his head and with his body close to the ground fanned his tail and made repeated runs at the interloper. As he ran, his spread tail swept the grass like a hovercraft. A blackbird was sitting on eggs in the *Lonicera* bush near the orchard. Another blackbird had a nest quite low down in the ivy.

The weather improved after a day of unpredictable showers. The sun was obscured by haze, promising a far better day. The golden celandines and daffodils in the clearing confirmed it was spring. The temperature rose to the seventies, it was the hottest April since 1949.

The *Fritillaries meleagris* opened their marvellous chequered blooms. Among them was the lovely white fritillary, sporting pure translucent bells hanging in profusion. There were also cowslips, rare these days. They have yellow flowers with orange centres and an exquisite perfume. They spread dramatically in the wet meadow.

Overnight, someone had erected a sign on the road. It read: *Toad crossing. Be careful!* It was the time of the frog and toad migration and people were picking up bucketfuls and talking them to the other side of the lane. Nevertheless, there were a great many lying squashed on the roadside. Those that survived would eventually disperse to the lakes at Marley house, the village pond and our own sanctuary. How they remember the ponds where they were born and then navigate their way back to them the following year is a mystery to me.

Tony lit the barbecue for the first time that year and we sat on the patio with a bottle of Chablis, kept cool in the top waterfall. The sound of the bottle being corked disturbed a cock pheasant: magnificent in iridescent gold, copper and red, he raised his metallic-green head, and he ran off into the copse. Throughout the spring he lost his fear and became quite tame, and would feed just yards away. The female would take corn from my outstretched

hand, until the cock called in the most fantastic manner. With his neck outstretched and wings open he would demand the hen return to his side. It always had its desired effect and she would run off.

Tony found four deserted eggs in a flowerpot that I had lazily tossed beneath a shrub. The eggs belonged to a robin. I removed two and placed them in a nest box among a clutch of blue tits eggs. On a subsequent visit, I discovered to my surprise that all the eggs had hatched and the blue tits were feeding not only their young but also two robin chicks clothed in black fur. I wondered whether they might have a identity crisis, once fledged.

A crescendo of chattering magpies alerted us and I knew that Gos has appeared again. After five minutes the magpies relaxed and took their annoyance out on the smaller birds. They swooped and drove them away from the food compound. Bracken stopped to investigate a scent on the broken-off tree stumps. As she nosed around I heard a rustle in the hedgerow. A tiny long nosed shrew slipped from her home among the dense foliage and quickly darted away.

Later in the day Michelle and I walked through the sanctuary to gather a blossom of each wildflower. We hoped to press and preserve them as a record of the flora native to the area. We came across huge drifts of wood sorrel. The clover-like leaves are green above and slightly purple beneath, pleated like a concertina and drooping gently. The large white five-petalled flowers, each with delicate purple veining, are exquisite. We picked only two for my flower press and placed them on some rice paper, which we folded carefully about them. The wood sorrel grows among the wood anemones, which flower at the same time. The foliage of the anemone is very pretty. Each leaf consists of three leaflets, which are often divided to the base of the stem. The name anemone is derived from a Greek word meaning the wind: hence the popular name windflower.

On our way back from the woodland glade we saw our resident fox, down by the stream. He stopped and shook himself like a dog, and glanced towards us with almond eyes. With no more than a sharp look, he walked slowly up the slope and into the depths of the woods. After he had gone a rabbit sat boldly in the sanctuary, ears constantly twitching. We moved and it bolted for cover.

The new trees and shrubs made phenomenal growth during the warm spells. In the shrub walk, ground cover plants nestled at the feet of some of the shrubs. *Cotoneaster hybridus Horizontalis* spreads out its fan-like branches as a dark-green carpet, but in summer a tapestry of abundant white flowers mingles with the green foliage to provide both nectar and cover. The small leaves turn orange before falling to reveal the prolific scarlet berries.

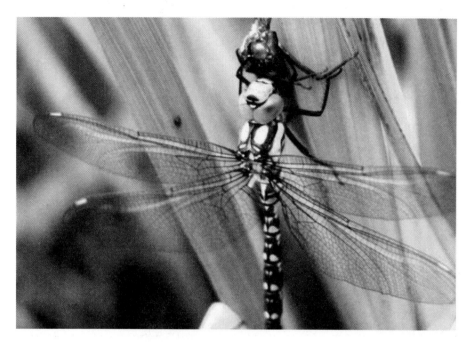

Dragonfly common hawker, Aeshna juncea

Convolvulus (Morning Glory)

Thyme clock

Aconites

Nuthatches on a food pole

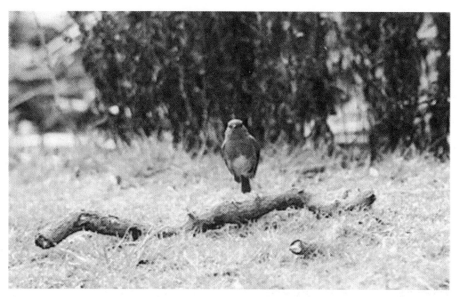

A robin sitting on a fallen branch

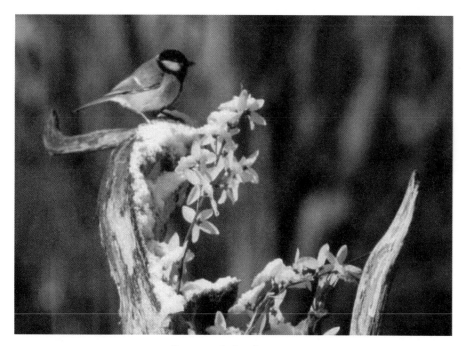

A great tit in the snow

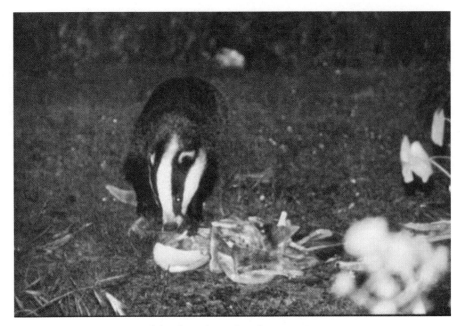

A badger foraging for supper

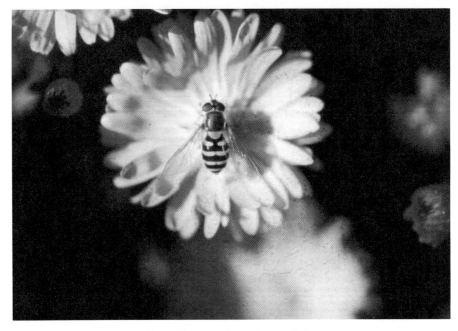

Hoverfly on michaelmas daisy

Dragonfly broad-bodied chaser, Libellula dipressa

Damselfly on water reed

Bombus locorum gathering pollen

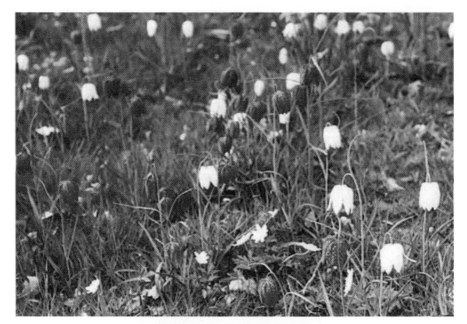

Fritillaries in the meadow

A snowdrop

Red poppy fields

Physalis franchetii

Pathway through the sanctuary

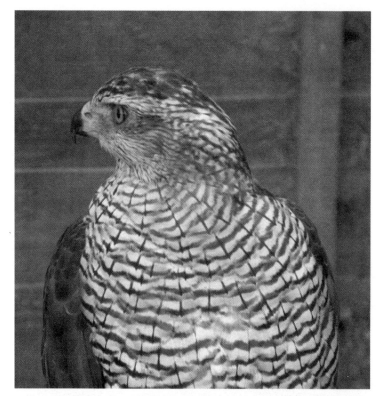

A rare goshawk

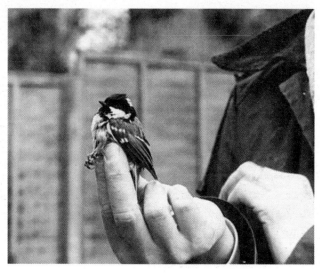

Ringing a coaltit

Fledgling magpie

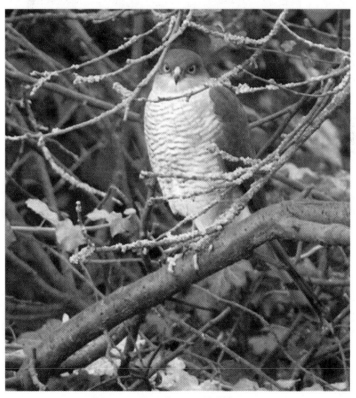

Sparrowhawk on wild damson

Leopard moth

Red admiral on snowdrops

White admiral on Coreopsis

Longhorn beetle

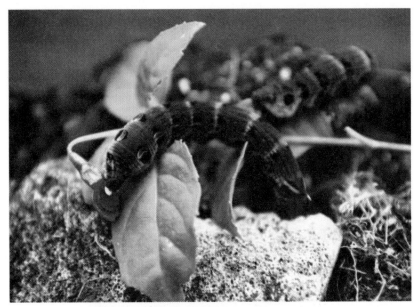

Elephant hawkmoth caterpillar

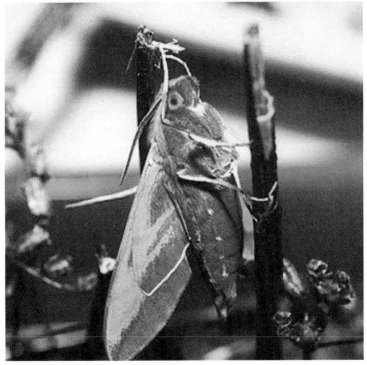

Elephant hawkmoth

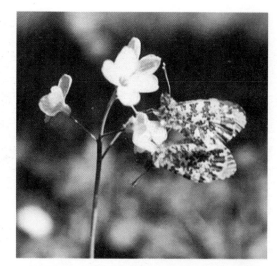

Orange tip butterflies on cuckoo flower

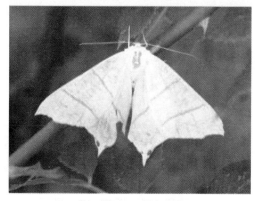

Swallow tail moth

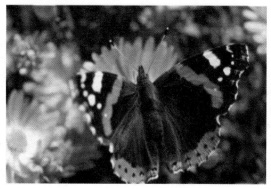

Red admiral on michaelmas daisy

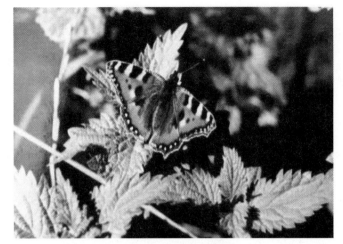

Painted lady butterfly

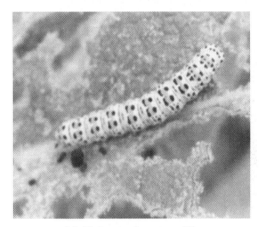

Mullein moth caterpillar

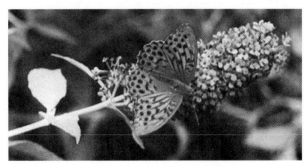

Silver-washed fritillary

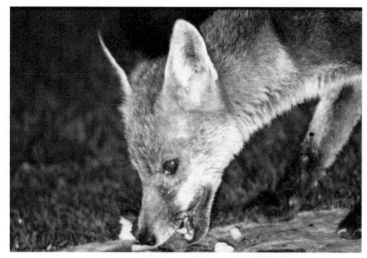

Russ taking food to his vixen

A blackbird about to bathe

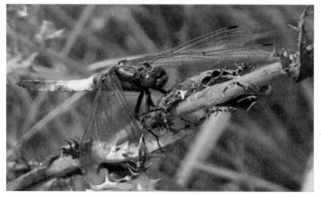

Blue dragonfly

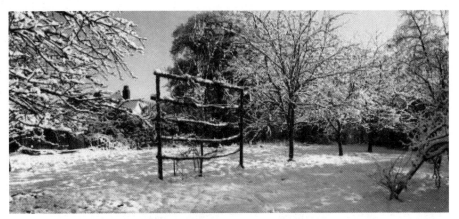

The orchard in the snow

Celendines in the snow

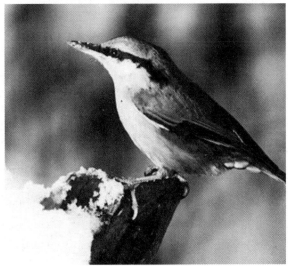

Nuthatch on a snowy branch

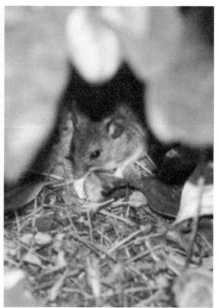

Peacock butterfly on stump　　　*A fieldmouse takes shelter*

The author in her meadow

In the summer, aubrietia in red, purple, and pink alongside masses of blue campanula and celandines with stars of gold would brighten the ground. The two skimmias had lost their dark red buds and turned into buff-coloured flowers. Those plants are male, but the female variety sport pure white flowers.

One of our nuthatches was plastering up a hole with mud from the lower pool in order to make it nuthatch size; no large bird could squeeze in to destroy the nest. A great spotted woodpecker drummed crazily and incessantly proclaiming her territorial rights to the world. As she made her way backwards down the tree her red-feathered skirt hid her feet.

A delivery van pulled into the drive with an order of shrubs and fruit trees from the nursery. But we were unable to plant as the hotel was extremely busy. The delivery included three Japanese maples (*Acer atropurpureum*) with large leaves of red-purple when the sun shines through them, *A. Senkaki* the coral bark maple with soft yellow leaves in autumn and conspicuous coral-red branches, and *A. palmatum Heptalobum* Osakazuki. There were also two buddleias for the butterfly population and a winter-flowering jasmine, all stacked against the fence in corrugated jackets until time permitted their planting. They matched the forestry commission's new planting of trees in their cardboard tubes.

The apples, pears and plums from the second parcel would be planted in the newly extended orchard near Hazel Copse. Apple trees rely on other apple trees being planted close by for cross-pollination. No apple tree is self-fertile although a single tree will produce some fruit. We chose trees that flower at overlapping times in order to be successful. Some insects such as bumblebees will search every blossom in a truss before moving onto the next one. The closer the tree is to the pollinator the more likely the bee will visit them both. The Bramley cooking apple with an acid yet sweet flavour is paired with Charles Ross as a pollinator (a cooking and a desert apple with a firm texture keeping its shape when cooked). Alongside these two varieties, Beauty of Kent, a Victorian favourite that is delicious to eat, is an additional second pollinator. Egremont Russet has Elisons Orange as its pollinator and the final two apples were Golden Pippin and Lord Derby because it is the finest cooking apple that I know.

There was a Victoria plum, a Reine Claud greengage and a Merryweather damson. I hoped that the wildlife would approve and give us time to harvest some of the fruit for ourselves before they sampled them. The deer are particularly fond of apples. The closeness of Hazel Copse should satisfy the squirrel population.

At four o'clock one afternoon I put out some mammal traps with the intention of recording the many species of small rodents in the sanctuary. It was my intention to inspect them within two hours and then release them: I didn't want any to die of shock. This happens very easily, especially with the shrews who have to eat constantly in order to survive.

At four–twenty I went to examine the six Longworth traps set out at four different sites. The first was placed among the rocks and rubbish beside the boundary fence, making it easy to locate. The second and third were under a hedge where periwinkle abounds, providing a thick ground cover protecting the wood mice and other small creatures. The fourth was at Eeyore's Place. Traps five and six at Hazel Copse had me searching frantically for fifteen minutes.

The Longworth trap has a nest-box about four inches square and six inches deep at the rear end. At the mouth there is a hinged flap and a tunnel leading to a chamber. A wire running across the entrance is depressed as an animal crosses it: this releases a trap door, and so secures the creature inside. I caught no unusual animals, only field mice, voles and shrews. I have caught at separate times two voles and a shrew. Hazel Copse was more productive: it yielded six voles, one shrew and eight field mice in a period of twenty minutes, implying that Hazel Copse is a haven for mice and voles. However, after one brief survey it is difficult to draw any real conclusion about the amount of small animal life in the area. I released them all: the mice jumped away in huge leaps, the shrews disappeared beneath the ground and the voles rocketed off into the undergrowth.

After the fifteen-minute search for traps five and six, the possibility that I may have been unable to find them played on my mind. I felt immense responsibility for those gentle creatures and the thought of them dying a painfully slow death troubled my conscience. Clearly I needed to mark the spots where the traps were situated. I hunted through the drawers of my desk and found three pairs of steel knitting needles. Sharp and strong, they would penetrate the hardest terrain. In my needlework box I found several yards of red ribbon. Reluctantly, I cut it into small strips and tied a piece to the top of each needle. When these were in their positions a guest asked if I was constructing a mini golf course.

The leaves of the snowdrops were starting to droop, highlighting the fact it was time to divide and replant them. The commonest variety, flora plena (*Galanthus nivalis*), is the most prolific. I have many other named varieties including the scented Sam Arncott, which had made a nice clump. The snowdrops were scattered over the woodland garden and when they ceased to flower my dog violets filled their places.

The shrub layer was crammed with interest, thick with briars, ferns (providing a backdrop of filigree) and nettles on which the tortoiseshell butterflies lay their eggs. Wildflowers flourished, including the brilliant lime-green *Spurge euphorbia Robbiae* growing in poor soil beneath the trees. On the rockery there is *E myrsinites* a trailing plant rubbing shoulders with *E Fens ruby.* The dark green foliage is lit with new growths of red, a pleasing combination, but beware: it seeds prolifically. The yellow heads of *E polychroma* are intensely bright. *Hellebore orientalis,* many of which have blooms of dark purple or rich red, has an extended flowering season. Among them is a rather choice variety with long plum-coloured petals shaded green. A carpet of lilac blue was spread across the meadow; I didn't plant the corydalis, yet there was a mass of it. The whole plant died back after flowering and disappeared without trace.

One morning it rained non-stop, becoming very wet underfoot and encouraging me to stay indoors for once. Michelle and David bought two shubunkin fish for the upper pool. They also purchased some water plants: arrowhead (*Sagittaria sagittifolia*), a plant with striking arrowhead-shaped leaves, and the lovely water hawthorn (*Aponogeton distachyus*), which has snowy blossoms with black anthers and a strong fragrance. The white petals were covered in black spots – as though an insect with dirty feet has walked over them. Michelle could not resist the tiny red water lily (*Nymphia frobeli*), which flowers in five inches of water. We placed it at the shallow end of the pool where the fish spawn. Over the surface of the lower pool, which contained no fish, frogspawn was suspended in clumps of jelly. Two frogs were clutching each other in a long-lasting embrace. Bracken crouched by the pool listening to the plop-plop of excited amphibians.

The pair of long-tailed-tits that we had seen a few days previous were darting to and fro, beside themselves with fury, scolding loudly at something hidden in the grass. At first we couldn't see the cause of the fracas but as the alarm calls continued with unabated energy, the black form of the woodcutter's cat stole stealthily through the stems. A thrush nearby, seeing the intruder, added his scolding message to that of the tits. Later in the day Tony located the nest: it was deep in the hedge close to our windows.

The hawthorns that form a hedge on either side of the sanctuary acted as a windbreak and the sun filtered through deliciously warm. The banks below were stained with pale blue puschkinias and the deeper blue grape hyacinths muscari. Four pieris bushes were showing off their lily-of-the-valley blooms among the yellow, red, orange and green foliage. One had almost finished flowering and the bright scarlet shoots of the season were covering the plant, prolonging its usefulness. I find it indispensable. Unfortunately,

for those gardeners who do not have acid soil it must remain out of reach unless grown in a large tub. The shrub walk was remarkably colourful with the double yellow-orange pom-pom flowers of *Kerria Japonica* that covered its long arms, attracting many iridescent insects. The first of the lilacs were in flower, the other lilacs poised ready to compete with their various coloured blooms.

The tourists were revelling in the warmth of the sun, and I met a group leaving Hill Farm, walking behind a herd of Friesians. The cows moved slowly along the lane, pausing now and then to snatch a mouthful of leaves from the hedgerow. They were being brought in for milking. I cut across the field to the farm and climbed the wooden stile, disturbing dozens of tiny insects as I walked. A small black-faced lamb, an early arrival, snuggled into a ewe.

Tony and I visited the tiny village of Burnley for a change. We found an enormous amount of flowers along Whistler's Lane, such as tiny cyclamen with picotee-edged leaves. Some of the leaves were beautifully marbled with silver, of the variety named *Cyclamen coum*, which in a mild winter may well flower in time for Christmas. They nestled beneath a tree on three-inch-high stems, presenting a charming sight in shades of pink. I also found a few white blossoms of the same species, with petals blown back like windswept hair. I bent down to smell them and found that they had no perfume and were growing in leafy woodland soil, shaded and protected from the cold winds by the tree amongst whose roots they nestled. Mice consider the corms a delicacy and will sometimes eat them in the ground. Our short walk revealed great diversity. In a hedge-lined lane, butterflies enjoyed the dappled shade from the midday sun. The most memorable sighting is of a black butterfly. It was gliding through the trees at speed on white-barred wings. The white admiral's underside is equally striking, with clear white bars on warm mottled brown.

Bob visited one day, to check the bat boxes. The first bat box that we examined contained five pipistrelle bats. We were both thrilled. The second box was empty but there was evidence that the bats had been using it. The third box contained three bats that started to move, so we quickly replaced the lid. Of the three remaining boxes a single bat was found in box seven. We were more than delighted with the results. Bats have a unique sonar system of high-pitched squeaks to prevent them injuring themselves when flying at high speed on their umbrella wings.

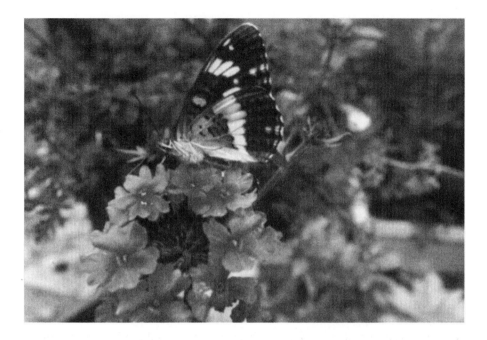

One day towards the end of the month I was up before daybreak to enjoy the sunrise. The sky was very dark, grey striped with orange and pink. Minutes later, the colour changed to yellow and the dark trees began to show their colours. A great orange ball rose above the conifers. In the increasing light I was thrilled to see the new cones standing upright among the branches, a lovely pastel green. Entranced, I stared in silence at its beauty, thankful for the gift of sight. The marvel of a new dawn always takes my breath away.

I crossed the glen in the company of two guests and we found that our feet were squelching in our shoes, for the dew lay heavy in the longer grasses. We followed the stream on its wanderings until we arrived at Burnley. As we crossed the fields to climb a stile at the junction of the lane, we heard a tremendous volume of song from the birds, confirming that spring had arrived.

Beyond the lane a securely locked five-barred gate was keeping a couple of horses safely confined within a field. I leant upon it and watched, captivated by the young foal at its mother's side. The mare, Patty, was used for drawing the farmer's cart, and around her throat she wore a chain necklace. The youngster decided that it was breakfast time.

Chapter 11
Bring Forth May Flowers

On the day of my birthday Tony handed me a large, intriguing package tied with a pretty pink ribbon. I opened it and inside lay the most wonderful of gifts. It was a night scope, designed for observing objects using only ambient sky light intensity. I could hardly wait to try it out. For the naturalist, May is an interesting month; the wealth of life it offers can only be touched on.

The stunning candles of the horse chestnut (*Aesculus*) flowered in shades of white, pink and red. Close to the *Ceanothus* covered in rich blue flowers stands a laburnum dripping with yellow pea-shaped flowers — a lovely combination. Early morning was the best time to walk through the sanctuary. The dawn chorus was an unbelievable medley of bird song. My feet disturbed the crane flies that were laying eggs in the meadow; the eggs would hatch into leather jacket grubs, which would feed on the grass roots. The sky was overcast and dull grey. Misty penetrating rain whispered through the trees. The dull weather depressed me, but my spirits lifted at the sight of our small goat willow *Salix caprea* Pendula, covered in long grey leaves. Earlier, it bore furry yellow catkins.

That evening, a very agitated couple came to the reception. The young lady was in tears. It appeared that a roe deer had jumped out of the sanctuary into the path of their car. We took our car the few yards down the road to assess the deer's injuries. He was unconscious and the slight trickle of blood from the nose looked ominous. We took him in our car to the vet. The injuries turned out to be less serious than we had thought at first, but we had to leave

him at the vet's for a few days. After that, we were able to collect him to return him to the wild. We named the deer Rudi for future reference.

After a mild damp night everything was covered in dew. The birds love the wet, and flutter about the shorn grass, scattering showers of quicksilver in which they bathe. The sanctuary was turning out to be a huge success: Mr Fothergill, Director of BBC's Wildtrack programme, telephoned to ask if he could visit us. We agreed on a time and date for the near future. As the day progressed, billowing rain clouds mottled the sky. We needed gentle rain, not the heavy downpour that rages for prolonged periods. At three-thirty that afternoon, a watery sun broke through a gap in the cloud layer, and bees returned from their enforced break to gather nectar. A fat white-bottomed bumblebee clung precariously to the blossom of a bluebell, which bent under his weight.

Wild arums were in flower everywhere. Most of them had spotted leaves shaped like arrowheads. They are known as cuckoopints or lords and ladies. In the centre of the plant, rolled up tightly like an umbrella, another leaf called a spathe protects the flower growing within. When this leaf opens, a long purple spike can be found inside, erect as a guardsman on duty. The folds of the spathe at the bottom hide the pollen-bearing stamens, knobs of different sexes, followed by the fruiting bodies. Above these, several rings of stiff hairs point downwards and trap tiny insects as they crawl down the stem. Once they are in this chamber, the stiff hairs hold them prisoners. After the insects have pollinated the plant, the hairs dry up and the insects are free to carry pollen to the next cuckoopint flower, where they are captured once again.

Near Hazel Copse, a secondary stream bubbled over fallen debris. After a heavy fall of rain, this stream gets repeatedly blocked and spills over the surrounding area. There are always a large number of deer slots and I quickly found some. The long slanting light is ideal for tracking. I found marks where a stoat had paused briefly. To my surprise, I found prints of a rabbit heading in the same direction. There was no doubt that the rabbit was there first, as one of the stoat's prints was superimposed on the larger print of the rabbit. I followed the tracks pass the old misshapen willow and climbed the rise towards Brockmere.

A spotted flycatcher sat on top of our small mock orange blossom (*Philadelphus Belle Etoile*) and from this heavenly perfumed habitat he made his darting attacks on the insects in the air.

Our foxes were very hungry. At eight o'clock — although still very light — One-Sided-Flash showed her face. Looking painfully thin and out of condition, she grabbed mouthfuls of meat and set off at a fast trot, presumably

to feed her cubs hidden in the sanctuary. Since Russ had died, the vixen had obviously left her cubs unattended while she came for food herself. She made eight journeys that night, taking all the food that was left out.

I awoke to a fabulous morning. A few days of perfect weather were just what the plants needed. Bracken and I walked up the hill, amid the smells of approaching summer. There was a scent of mown grass and the delicate perfume of the wild cherry blossom. Filmy pale blue forget-me-nots tinged with pink were scattered about the sanctuary floor, and their yellow eyes matched the new yellow shoots of the mosses perfectly. For me, gardening is a therapy. I enjoy the earth beneath my fingernails, the warm air on my face and the strange aromas of the peaty soil. In particular, I am one of those rare people that enjoy weeding. However, there are guests to look after and housework to be done.

The hawthorn intoxicates with its sweet smell like almonds. Once the insects have pollinated the bush, the smell became quite unpleasant. Our hedgerow provides shelter for a rich variety of wildlife, not only the birds, but also insects of all kinds such as thrips, beetles and worms. Beneath the hedge, primrose, meadow cranesbill, cow parsley, cats ear, sweet cicely and fungi have taken hold. Long-legged wolf spiders and the tiny green crab spider lurk among the leaves. On one occasion, I observed a creature shaped like a shield, very handsome in green with bands of orange along the sides and over the shoulders. It was a hawthorn shield bug. I discovered several more on the leaves and stems.

I kept the promise I made to myself earlier and returned to Hazel Copse sett, where I took up my position close to an oak tree about six feet away from the entrance. I felt a moth flutter against my face. A large moon shone over the copse, casting shadows of the hazel clumps across the sett. I could just distinguish the lights of the hotel.

After a twenty-minute wait a badger emerged and wandered so close that I was unable to focus the camera on him. He shuffled off down his well-worn pathway towards the hotel, anxious to partake of the food left out for the foxes. Before I left the sett, I was rewarded by the sight of two more badgers who stole from the entrance and made off along one of the badger paths towards Bluebell wood. The woodland floor rustled. A young woodmouse came into view, eyes large and luminous, scurrying nervously along the track. He found an acorn and, sitting upright with the fruit between his feet, nibbled it delicately. I ducked beneath the brambles that form a thorny barrier and cursed my luck as the barbs ripped the sleeve of my duffle coat. Worse still, I upset the woodmouse as I gave out an involuntary cry of annoyance.

Morning broke, bringing with it a fresh burst of rainfall. It turned into a heavy shower, raindrops lashing across the gap in the holly bushes. It washed clean the leaves of the silver birch. I sat quietly in my prickly shelter, listening to the sound, watching the water drip from the end of each serrated leaf. On the floor, the pale green leaves of the wood sorrel thrust through the peaty soil. A worm pierced the earth and wriggled his way across the leaf litter and over my boot. It was a scene of great interest, teeming with life.

In the holly bush, ten feet away, were four greenish-blue eggs mottled with brown spots, cradled in a grass-lined nest. They belonged to a blackbird, whose mate's antics were fascinating. He alighted on a nearby branch, his feathers darkened by the rain, and shook them into place before he started to preen. His yellow-rimmed eyes scrutinised the hedgerow, then he alighted near the edge of the nest. Since the first egg had been laid, the pair had been mobbed constantly by a couple of magpies. The magpies had chosen to nest high in the topmost branches of an oak, very close to the road. Blackbirds are often the targets of magpies and I fear for the safety of their young once they hatch. Raptures are not the only predators of the bird world. I once saw a great spotted woodpecker alight on a bird box and tap gently until a tiny head appeared. The woodpecker then quickly snatched the young from the box.

There was so much to see and do in the sanctuary as it developed and changed daily. The snowdrops and crocuses were gone, but in their place a sea of blue ran from the hotel deep into the woods. Nothing can compare with the carpet of bluebells, before the canopy of leaves above blocks out the light. Rose campion was just coming into flower at the sanctuary boundary. My lovely welsh poppy (*Meconopsis cambria*) was in flower in a shady border. Bright yellow flowers surrounded by light green foliage brought a touch of sunshine to an otherwise drab corner.

I photographed a male marsh tit showing aggression to a great tit as they were perched on the same bag of peanuts. The nest in the tangle of clematis contained eight tiny offspring covered in soft grey down; their pinkish-orange mouths with yellow flanges wide open. The parents fed the young on late-hatching caterpillars of the oak tortrix moth. There were literally hundreds of them, suspended by long silken threads. During the previous year, Oxford Scientific Films spent a considerable time in the sanctuary with a video camera. They made a film for Channel Four television called *Enemies of the Oak*, and filmed the caterpillars and other relevant subject matter. The bright-eyed *Phlox Douglasii* is a fine butterfly plant and the orange-tip butterfly is quick to exploit this source of nectar. Apart from the

orange-tips there are a few peacocks and tortoishells, which over-winter in the garden. The only other coleopteran visitors are the cabbage whites.

I wished I had the courage to edge a particular border with dandelions; I simply adore their cheerful golden blooms. On reflection, I realise that I played a large part in their cultivation the previous year, dispersing seeds everywhere when I played dandelion clocks with my tiny grandson. Among the grasses in the meadow is *Deschampsia flexosa*, usually known as wavy hair grass. Also growing there is the steel-blue *Helictotrichon sempervirens*, showing spikelets of oats.

The weather was fine and we were determined to plant more herbs near the butterfly borders. Many people grow herbs for culinary purposes but are unaware that they are often the best wildlife plants. Bees literally get drunk on the nectar of *Allium Globe master*; we find many bodies lying prostrate on the ground. The first plants to go in were the lavenders as they were to form a hedging. Behind them would be the silver leaved santolina.

We had plants for bees, plants for insects and butterflies and of course edible useful ones for us. There was mint for the magpie moth to feed on and to add to the leg of lamb for dinner. There were alliums with purple-fringed flowers, marjoram, basil and sage with variegated leaves, soft and downy to touch. Some flowers are deep indigo blue, others as azure as a summer sky and all with thick furry foliage. It was intended that my herb garden was to be more than just a collection of plants. Facing south on sandy gravelly soil, the plants enjoy the warmth. Parsley is not only used intensively in our culinary dishes, but its dark green feathery foliage acts as a foil to other herbs. We planted fennel or ladies bedstraw for the butterflies, and coriander, an eastern spice used in curries.

Sweet cicely (*Mrytus odorata*) is better known as chervil, and resembles the poisonous hemlock. Its leaves turn purple in the autumn and the plants smell of aniseed. It flowers early in May. The pink thrift, like flowers of chives, brighten up the border and both flowers and stems can be used in salads. There was also rosemary and dill and sorrel (*Rumex acetosa*), which is the food plant of the small copper butterfly. It is planted in sandy soil, as is the fragrant *Chamomile anthemis Noblis* whose leaves are silver and its flowers white. All these herbs must be allowed to flower in order to attract the insect population. Of the mints we had spearmint, apple mint, pineapple mint, ginger, eau de cologne and mountain mint.

Hoverflies and ladybirds were welcome predators, eating the aphids on the plants. Cardinal beetles resemble the lily beetle; both insects favour the parsley. However, the striking red lily beetle is a serious pest on the lily family. Swiss chard is included as its red stems and veined leaves are so

beautiful when lit from behind by the suns rays. We grow it by the pool instead of rheum, which we felt would grow too large.

Tiny soldier beetles arrived in droves to visit the red valerian. My greatest joy was the sight of a humming bird hawk moth as it sipped nectar from the flowers. Hovering like a kestrel, it took lunch on the wing.

Over the years, a great many insects and butterflies have made the area their home. The garden spider with four identifying spots on its back weaves its sticky web among the herbs to catch its prey. Delicate green lacewings visit the flowers and the mullein is irresistible to the moth of the same name. The nasturtium flowers are candied to add to deserts and their peppery leaves are tossed in salads. Lemon thyme is a must; this aromatic hybrid attracts bees by the hundred, just as excited as I am by the presence of this plant. Lemon verbena is a larger plant and its perfume can be smelt strongly at the sanctuary border.

Even the common groundsel (*Senecio vulgaris*) is allowed to grow here. Wild chicory is a very desirable plant and I am amazed that no plant nursery ever offers it as a border plant. It may prove a bit straggly, but no one can improve on the intense blue of the daisy heads. I planted seeds of ox-eyed-daisy, pink hawksbeard, aquilegia, woodruff, everlasting sweet pea, corncockle, evening primrose, heartsease, foxgloves and sunflowers.

We planted the low growing species of thyme, which needed to be placed in a position where they could easily be seen. I decided that herb wheels were too low, so I purchased two and placed one on top of the other. We discovered that this works very well, but I wanted to attract not only the wildlife numbers to the area but people as well. I stood looking at the wheel, and thinking about the thyme planted in it decided to place the numbers twelve, three, six and nine around the edge. I then asked Tony if he could make a pair of clock hands. Painted black with the arrow shaped pointers lacquered in gold, they looked impressive. I set the time on the herb clock to 3 pm: an invitation to the insects and butterflies. The profusion of nectar amazed the bees and insects. The great spotted flycatcher also took advantage of the situation, swooping with glee on the insects, making me feel like a murderer.

A ring on the reception bell took me to the foyer. I was surprised to see Bob surrounded by guests. In his arms was a young fox cub about seven weeks old. He told me that her name was Jenny and that Mr Albert Honey of the RSPCA has given him the cub to look after until it was old enough to release back into the wild. The young creature already appeared to be fairly tame and allowed me to cuddle her. She still had the chocolate-brown fur of babyhood and appealing puppy eyes.

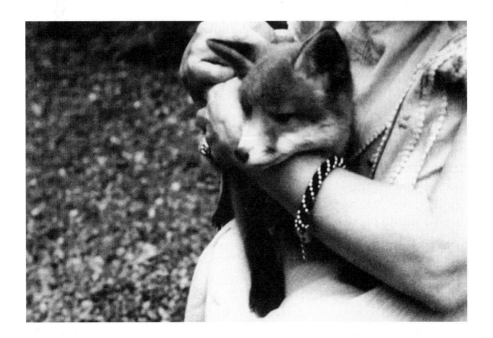

We wandered through the spinney, a quiet leafy place with a distinct smell of leaf mould, and we found a small tortoiseshell butterfly basking on a solitary dark green leaf. The rank smell of old winter vegetation still hung around the stream, despite the new growth of the nettles. We spent only three quarters of an hour roaming around, as the hotel was extremely busy with the first of our summer visitors.

I gazed out at the beauty of Stony Wood. As soon as the sky darkened, One-Sided-Flash stole in through the undergrowth, leaving her cubs with an admonitory yap to stay out of sight until she returned. A movement among the foliage alerted me to her presence. The lights were full on, revealing her perfectly. I could see the large pricked ears, a soft grey inside, and her white bib. She crossed the lawn, picked up a large piece of chicken, and returned to her young, covering the ground at speed. Her cubs were probably between six and eight weeks old and would soon make an appearance.

Before I went to sleep, I set the alarm for six o'clock. This was never necessary: I always woke up, every day, at precisely five–forty. The following day, the weather was fine, with soft billowy clouds in a blue sky. I walked with Tony through the sanctuary. A hoverfly zoomed over the grasses, and I mentally compared it with the humming bird hawk moth that I had seen previously. Both had the ability to appear motionless. When we reached the river, a honking drew our attention and a lone Canada goose came into view under

the bridge. There was a rush of wings high above and a great flock flew in, honking crazily, to drop into the cold grey water. Skeins of swans were visible to the south, black against a teal-blue sky. At the water's edge a wagtail slate, blue and sulphur-yellow with his tail bobbing all the while, conducted a thorough search for food along the muddy shore.

On tiptoe, we quietly crept under the bridge, moving slowly to the western side of the privet hedge where we hoped to discover a long-tailed tit's nest. For several weeks she and her mate had been busy gathering material. I had watched her on previous occasions. Sure enough, there was the nest woven between the forks of two branches. Both sexes play an active part in building the oval-shaped nest (working from the inside) of moss, cobwebs and hair, decorated with lichen and crammed full of feathers. We left, satisfied that she would rear a brood. There was no need to check the nest. I would never forgive myself if my attempts to see the tiny bird resulted in desertion of the eggs.

We wandered up the lane, full of flowers. As the track passed through the farmland before it turned down into the dell, we had fine views of the city spires. Forking right, we became aware of a change in the surroundings. There was a blaze of scarlet poppies in a field to the east, with the sky-blue flax (*Linum perenne*) in an adjoining field. They looked so wonderful together that I shoot a whole reel of film. It was a picture so perfect any artist would find it difficult to emulate. The variety of waving grasses and red poppies formed a sea and as the sun began to warm the slopes, the butterflies emerged: meadow browns, tortoiseshells, peacocks and orange tips. These were all the species that we were trying to encourage to breed in the sanctuary. Standing there it was hard to believe that only the previous year that field was used for arable farming. Now that the farmers were laying fallow some of their fields as recommended by the EEC, the fields were returning to their natural state.

Along the lane we meet a full-grown fox searching the earth by the hedgerow: a marvellous photographic opportunity. Caught in a shaft of sunlight, he was magnificent.

A long mellow limestone wall flanked one section of the lane. Warmed by the sun, many wild creatures have made their homes in the holes and crevices such as lizards, stoats, spiders and snails. At the foot, moles, mice, lizards and sometimes weasels are found. In the smaller holes, various wild plants have taken root, such as the fern, spleenwort, and the soft silvery-grey leaves of the foxgloves (*Digitalis purpurea*). A single purple saxifrage, a garden escapee, trailed majestically over the stones to find a niche lower down. The far end of the wall was covered in brambles, whose roots were deep in the damp rich soil of the woodland. Their long trailing arms stretched

across the wall, convenient for blackberry pickers. During May they were aglow with beautiful white flowers and fluttering butterflies. Among them a solitary valerian was in flower, glowing a dusky pink. The green foliage of a polybody fern enhanced the scene.

Walls are best for spider watching; the web of the funnel spider is a miraculous piece of engineering. At the lower end of the wall, mining wasps and bees had attacked the mortar. Generally stonewalls are erected without mortar and constructed with local stone. The wall matched the stone of the nearby cottages and had been renovated at its far end where the mortar was in evidence.

I clambered over the wall to return by the woods, only to be welcomed by a large stand of stinging nettles for my trouble. The large funnel-shaped leaf and purple spike of the finest cuckoopint I had seen that year attracted my attention. These plants tend to grow in shady places, and that one was no exception. Although certain it would be a failure (due to poor light) I took a photograph anyway.

The young bracken was just showing through the woodland floor: two or three fronds were unfurling. They reminded me of upside-down seahorses. The golden flowers of the common gorse (*Europaeus*) set alight the banks of our hedgerow. What a vivid display they made. There was a smell of freshly-mown grass in the air. A collar dove cooed incessantly above the stream, a soft low note.

Wind flowers (*Anemone nemerosa*) covered the sanctuary floor. These flowers are quite exquisite, trembling on thin stalks, revealing a purple back. We never pick them, as — like the field poppy — they wilt long before we can get them back to the hotel. A glow of pink among the bluebells caught my eye. It proved to be an orchid with speckled leaves and long spikes.

Bracken, Tony and I walked about two miles and listened to a thrush singing near Croswell pool. I was delighted to see marsh marigold (*Caltha palustris*) in full flower, rising from the depths on thick fat fleshy stalks. The shiny wet-look flowers matched the paler goldfish in the pool perfectly. They deposit their eggs on the undersides of the leaves. I noticed that the ramshorn snails in the pool had multiplied dramatically. They lay their eggs next to the goldfish. I gently lifted a leaf to see the jelly-like eggs of the numerous species securely fastened on the underside.

The magpies and crows gave away the whereabouts of the foxes, diving on them, shouting annoyance at their visits. It is an anxious time for all the wildlife, and there is a lot of playacting: birds take on the role of Long John Silver as they limp and flutter over the ground, to lure would-be predators away from their nests.

High mortality among the young is due to lack of experience. When I see fledgling birds sitting in the open, beaks agape, I wonder that anything survives.

Chapter 12
Wildlife Action in June

The brilliant sunshine streaming through the windows woke me early. The long balmy evenings of midsummer, embellished with roses and honeysuckles, were back. Sweet peas adorn the vegetable plot, grown in the old-fashioned way on pea sticks. I save our own seed and sow half in autumn and half in spring to prolong the season. The first day lily had opened its yellow trumpet. The throat was suffused in deep coral pink and copper reminding me of the sunset that I had experienced the previous night. Although the flowers only last for a day, there is always a succession of buds waiting to follow.

Bracken, as usual, had followed me outside, wandering around with her nose to the ground. She sniffed for information as to who had visited the garden during the night. I could have told her, for I had stayed up in the company of the foxes, the badgers and the deer. The flowers washed in dew looked as though they had been sprayed with lacquer. There was an indescribable freshness. The softness of colours deepened as the light grew and Bracken and I moved from scent to scent.

The rose Canary Bird was covered with golden-yellow single flowers that had first appeared in late May. The texture of the blooms is soft and silky. They flutter in the breeze like brimstone butterflies. The sanctuary had grown enormously that year — the butterfly borders, the rose beds, and my enchanted evening garden enticing a wide variety of moths. The white buddleia is well placed behind the pale mauve *Buddleia alterifolia,* and immediately to the left are two skimmias bushes, flaunting white blossoms.

The same bushes in the winter are massed with colourful red berries. On hot nights I sit in this area close to the pool and watch the many species of hover flies and soldier beetles. They ignore the butter-yellow irises and alight on the paler trumpets of the honeysuckles.

I walked down the hill to the drone of combine harvesters; the winter-sown crops were being brought in from the surrounding cornfields. A plume of smoke on the skyline indicated that Hill Farm's stubble burning was already in progress. In the rough hedgerow, I found ivy leaf toadflax and herb Bennett, with tiny yellow flowers. A small dark butterfly flew through the top of the hedgerow. I could not confirm its identity until it finally settled on a leaf. It was a butterfly that rarely comes within twenty feet or so of the ground, preferring to fly in the oak canopy. On the upper sides of its wings was a glint of purple: it was clearly a purple hairstreak. Vivid tortoiseshells, elegant commas, and warmly coloured meadow browns were abundant.

I counted six magnificent silver-washed fritillaries sipping nectar from the buddleias and a number of hairstreaks. It had taken eight years to encourage the silver washed fritillaries to grace us with their presence. The butterflies and day flying moths were out in full force. The first creature we saw was a cinnabar moth, conspicuous with its red and black wings. It presented a vivid splash of colour as it skimmed across the meadow. Those winged jewels make the summer exciting. Another moth on the wing was the poisonous six-spot burnet. The hind wings are scarlet and the front wings are a blue-green with metallic red spots. The butterfly feeds on birds foot trefoil, clover and vetch, all of which I planted in the wildflower meadow. As they live in colonies, there will be others nearby.

The grasses in the meadow provided a gauzy veil of green, buff and silver with touches of delicate pink. I had never seen the meadow looking so beautiful, with whispering waving heads of Yorkshire fog grass and the annual fluffy cream decorative heads of eared grass hares tail (*Lagurus ovatus*). Wood melick grows here naturally, a perennial throwing up of loose panicles of chocolate-brown spikelets. There are so many grasses in the meadow, some with names that I have forgotten. Quaking grass is one of my favourites. It is delicate and pretty, with many seed clusters dancing and bobbing in the slightest breeze. I can remember planting Yorkshire fog, Sweet vernal grass, Meadow foxtail, Lyme grass and Fescue. The other grasses came in a mixed packet of wild grass seed.

Greater knapweed mixed with the spikes of agrimony, yarrow, meadow vetch and meadowsweet, which were all in flower, filling the air with an evocative scent. A strange fly settled on the flowers of a clump of mint. It was so unusual that I took a single photograph of it to help me identify the species.

I had noticed that the smaller the birds, the more intricate and architecturally beautiful their nests are. The larger birds — pigeons, rooks, crows and hawks — all have untidy, perilously sited platforms of twigs. The birds would not be so noticeable if they sat tight-hidden by leaves and thorny branches. Instead, they rocket away, protesting noisily, drawing attention to where their eggs and young are.

June is the month of flowering shrubs. Trees have their heyday in April, although the elderberry (*Sambucus*) was massed with flamboyant flowers. The heads were as large as dinner plates, as lacy as doilies and with a sweet scent. True geraniums are really hardy. We have Johnson's blue which flowers from midsummer to early autumn, and *Geranium endressi*, a gorgeous pink whose blossoms glow in the early morning sun. By midday, the roles are reversed and the pink colour is less eye-catching. I find shades of pink restful; I place them next to the misty blues of love-in-the-mist (*Nigella*) and catmint (*Nepeta*), which have the added benefit of grey leaves. They provide a cottage-type atmosphere. Silver-leaved plants are at a peak in high summer and are further brought to life by the warm tones of *Phystostegia* and pink day lilies. A large clump of the feathery silver-white foliage of dwarf tanacetum takes its place at the end of the border as a stop plant. Its leaves are thick with a fur-like texture. Another grey-leafed plant of merit is the artichoke with large exquisite foliage. This plant is so impressive it can't fail to be noticed.

To its left is the bold vibrant colour of the crane's bill (*Geranium psilostemon*) intense magenta-pink flowers with a black centre and to the back of the border are some stately foxgloves. Spire after spire of noble flowers dangle abundantly, the purple-pink or white bells exquisitely patterned. I lifted one gently with my finger, upturning it to look inside the bloom, spotted fantastically. They spread from the border through the sanctuary. The ferns send up nodules of furled coils like an emerald-green punk hairstyle.

The flamboyant oriental poppies express the mood of June, silky blooms in a blend of fruity shades creating a great border perennial. After flowering the leaves tend to turn brown, but a quick trim and a fall of rain bring new buds shooting from the earth and a second crop of blossom. It is important to have a variety of cultivated plants alongside our native wild ones to extend the potential larder.

Wildlife is at its most active in June. Caterpillars, moths, beetles and greenflies munched their way through tons of vegetation. In the herbaceous border, hoverflies like miniature helicopters lowered themselves gently on the flat heads of Queen Anne's lace. The sun's rays glistened on the metallic armour of the flies: iridescent green, bronze and blue.

The entire hedgerow was burgeoning, with tall feathery grasses and wildflowers swaying gently in the breeze. There was ox-eyed daisy, corn marigold and cornflowers with butterflies dancing over the surface. The field beyond rises steeply to a bank that was hung with masses of wild mauve buddleia: a wonderful sight. I breathed deeply, taking in the wonderful scent. Along the ridge I came across a fox earth. It emitted a strange musty odour and I paused, wondering whether the cubs I had seen in the sanctuary had used it in the past.

All was not well, however. A survey on the trees in the woods, to determine their danger to the public, had alarming results. When a tree had fallen on top of a car during a storm the previous year, a passenger was killed and two others were injured. Teams of foresters on a five-year contract were removing trees at alarming speed. I wished that they would be more selective but it appeared to have been decided that a path twenty feet wide had to be cleared from the perimeter regardless of what trees, shrubs and flora were growing in the area.

The following day brought a gem of a morning, the brilliant sun filtering through the trees. All around the hide the grass was adorned with hundreds of tiny cobwebs hung out like fairy quilts to dry. The sparkling dew revealed what would be invisible on a hot dry day. Each cobweb measured about two inches, almost perfectly square. With the scorching weather some of the plants looked wilted but the beautiful *Harebell campanula Rotundifolia* was in full bloom, overloaded with hundreds of exquisite blue bellflowers. Our native harebell had washed the sanctuary in pure Wedgewood blue. The hanging bells dangled from slender arching stems.

The insects had been hard at work destroying the new growth from the beginning of the month. There was a fine display of modern art covering the leaves at Hazel Copse. The blackberries were suffering from the attention of the leaf miner; graffiti squiggles of white zigzagged-lines had been executed at random. They belonged to the larvae of a moth. The sawflies, not to be outdone, had stripped the leaves of my dwarf elm. This was a great pity as it had been left tattered and torn.

In the sanctuary are two wonderful plants trying to outdo each other for attention. The soft-spotted leaves of the pulmonaria are very striking but the filigreed sculptured leaves of the silibum thistle remind me of the silver-sprayed foliage you can purchase from the shops at Christmas. Also planted in the border is Russian sage (*Pervoskia*). The silvery fragrant foliage is strung along the entire stem with lovely blue flowers. Like all sages, this plant has a pungent smell. In the vegetable plot the birds had already

discovered the miniature fruit of our prolific wild strawberry. Planted in a south-facing border, they fruited very early.

While fishing the ever-persistent blanket weed from the pool I netted what I thought at first glance to be a lizard. The wriggling creature was lifted from the murky depths. It writhed in the net within in the rotting vegetation that had also been scooped up from the bottom. Looking more closely, I could see that it was a newt of a uniform olive-brown colour. I was just about to release her back into the pool, when I noticed that her mate was basking on a ledge. The difference between the female and the more striking male is remarkable. The male's most prominent feature is the fine crest that extends along the male's back and down his tail, like an undulating ribbon with a wavy edge. The colour is extraordinary; my miniature dragon sported yellow–orange black-spotted under parts. There was a fine blue line the length of the tail, which ended in a patch of vivid orange.

An amazingly coloured dragonfly darted over the pond's surface on four wings of silver, cross-hatched with veins of dark brown, hawking for insects. There were plenty of midges dancing their aerial dance. They attacked every unclothed part, causing me to dash indoors for the insect repellent. I returned to find the newts gone.

As I peered into the murky depths a fat frog swam from under the star-like flowers of the water lily. The floating arrow-shaped leaves of *Sagittarius* contrasts with the upright stems of the corrugated rushes *Festuca amethystina*. A clump of blue grass *Miscanthus* nestles in a corner. They are among the best ornamental grasses, being attractive in both leaf and flower. An exotic black grass present in the sanctuary is *Ophiopogan miscanthus*. It bears pale pink blooms and after flowering, dark blue-black fruits and is related to the lily family. A damsel fly was perched delicately on a blade, her body gleaming like polished steel in the sunlight. The end of her abdomen was a vivid blue. A tiny insect landed close by; it had minute pastel-blue green wings attached to a small brown body. It lifted its tiny wings and before I could identify it the insect flew off.

There were so many dragonflies — the first I had seen in the sanctuary since it had been completed. I tried to photograph all the species and found that some were more difficult to creep up on than others. The darters are very fast flyers and seldom settle. They seem to patrol territories darting too and fro like aircraft in a war zone swooping and diving on their prey. A water boatman sculled across the surface of the pool. Its modified legs, adapted for swimming, look remarkably like paddles propelling the insect across the water. The water boatman can also take to the wing, as can our diving beetles.

It was only ten o'clock one morning but already the thermometer was hovering at the eighty–degree mark. By lunchtime, the heat was unbearable. To make things worse we had lit the barbecue, which was sending up thermals. Even the blackbird had chosen to stay in the shadow of the shrubs, taking pauses between hops. A newly hatched dragonfly was poised on a reed in front of me. Four lacy brown wings were stretched out to embrace the sun. The wings trembled before it flew off between the oaks, returning every now and then. Sometimes it was lost to view, but when it was caught in the light of the sun, it took on a magnificent burnished hue as it twisted and darted above the pool.

Something among the heathers caught my attention, a curious white undulating ribbon. On investigating, I discovered it to be the sloughed skin of a grass snake. The eye sockets could be clearly seen, as could each scale along the body. The creature had wrapped itself around the twiggy growth, and moving slowly forward left its old ill-fitting skin behind. Before leaving the heath I counted another four skins of varying lengths.

While out for a stroll I noticed that the yellow lichen was abundant. Even a small branch contained a seething metropolis of flora and fauna. These microhabitats can support a vast number of invertebrate species. While foraging for other lichens, I noticed two more hollows. It occurred to me suddenly that I had stumbled across a new badger sett. I found six holes within a radius of ten feet. Two were newly excavated and huge piles of sandy soil lay at the entries.

As I was leaving, a green woodpecker flew in without a sound to investigate the soil. Without any apparent reason, it began to dig furiously. Clumps of moss flew through the air as the bird hacked away with his powerful beak, lifting his head every few seconds to glance quickly around. Dressed in yellow and green, the green woodpecker is a handsome bird and the largest of the three species in the sanctuary. The scarlet-crowned head of this newcomer moved in rapid jerks as he probed the ground. Soon he upturned an ants' nest, and distraught insects rushed hither and thither, oblivious of their own danger, to carry larvae from the nest. After a quick lunch the bird flew away with a burst of insane laughter.

To my delight, I discovered a single purple orchid. Maybe it is one of the commonest varieties, but it is in our sanctuary. The orchid has a rather unpleasant smell and striking spotted leaves. The Japanese quince (*Chaenomeles*) were in full bloom. I planted the species crimson and gold, and the variety (*Moerlosii*), a lovely apple blossom pink. Its arching habit has built up over the years — tier upon tier — giving it the appearance of a domed shrub. It is especially liked by the robins and wrens, which seem to

spend half their day flitting through its branches. The rest of the border is occupied by collections of herbaceous plants chosen for the butterflies: sedum, Michaelmas daisy, trefoil, lavender, anaphalis, verbena, statice and scabious. In time, the garden will reach a stage where I can consider it fully acceptable as a sanctuary.

Blue shadows of a late evening stole slowly through the copse, and with them come the awakening of the wildlife in the woods. The harsh screeches of the jays were at last stilled. Low murmurings took their place as the birds settled to sleep and the slow-flitting moths emerged beneath the oaks. A full moon hung in the sky like a gigantic silver coin, craters visible, and the woods became alive with the sounds of the nocturnal creatures.

The gentle 'Whoo-woo' of one of Brockmere's tawny owls floated on the air, and minutes later he glided slowly past me on silent wings. From where I stood I could hear the gurgle of the stream, passing between the sedge-bordered rocky banks. Then, in total contrast, came the scream of a fox high on the ridge — unusual for June. It was time to get into my hide if I wanted to watch the badger cubs at play. The adults would have left the sett at twilight to go on their nightly forage. Soon, several enchanting cubs appeared and sat in the entrance. They were growing fast, miniature replicas of their parents. From my hide I watched them at play. Shortly after the adults left, the charming triplets had a game of tail chasing, accompanied by excited snuffles and grunts. The delightful creatures bounced up and down on stiffened legs, looking so comical that I laughed aloud and in fright that they would chase after their parents.

Later that night I was watching the foxes from the patio door. Carrying the last of the sausages in her mouth, One-Sided-Flash moved away, ignoring the bones. Her jaw was crammed so full that she continually dropped them and was obliged to stop several times to retrieve them. She finally trotted off with sausages trailing from her jaws. To my delight a small cub, fed up with waiting, darted from the bushes and grabbed the end of a link, holding on to it tightly as he trotted off behind mum.

Neither Jess nor One-Sided-Flash were the first to appear on the scene the following evening. The adventurous cub from the previous night bounded out puppy-like to take some food for himself. I heard the sharp bark of the vixen as she summoned him back to her side. The young cub was well grown but to my consternation appeared deformed. His hindquarters were a good few inches higher than his front and his tail stuck out at an acute angle (like a horse's tail) for about five inches, then drooped sadly, coiled like a S-shape in reverse. The cub was otherwise alert and healthy. One-Sided-Flash and

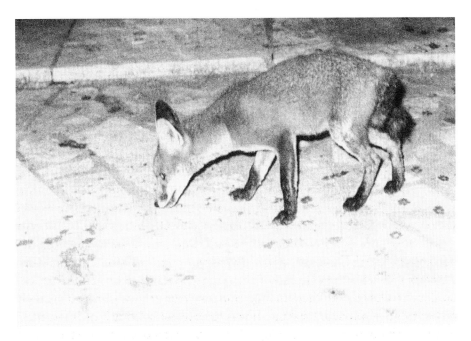

Crank-Handle stayed feeding in the quietness of the evening. Tony had fenced off the garden around our living quarters so that both the foxes and I were not disturbed.

The next night, Crank-Handle arrived at nine o'clock. I watched him creep alongside the rhododendrons where I knew that at least one other cub was hidden. The arc lights were full on and I wondered how Crank-Handle would react. He kept his body in the shadows until he was level with the food and then, stretching to his utmost, seized a piece of meat and retreated with it into the undergrowth with a yap of excitement. One-Sided-Flash had taught him well. As the evening progressed he became braver and, once all the food he could reach from the safety of the shadows was gone, he came fully into the light and I made some quick sketches. The lights of the hotel were being switched off one by one as the guests settled down to sleep. I was seated in an easy chair facing the patio doors. At ten pm the vixen ventured out. One-Sided-Flash seemed more wary than the cub and made lightning dashes for the food. No other cubs made an appearance.

The hotel is our bread and butter and must come as our first priority. As I served breakfast to the guests the light filtered through the trees, touching the grey trunks of the ash. I let my gaze wander the length of the garden, over the flower borders and across the sunlit meadow, stopping at the pool. Rafts of water lilies floated on the surface, their blooms fragile and perfect.

A small bird took a bath in the shallows, and splashing water over its body and the immediate area. When it eventually flew off I could see clearly that the foliage of the ladies mantle (*Alchemilla mollis*) was covered in droplets.

I was able to get out for a few minutes that afternoon. Clouds of pollen drifting in the air made me sneeze. The hawthorn had replaced elderflowers, attracting a large variety of insects. The giant hogweed towered above tall grasses and meadow vetch. Many a year I had collected the elderberries to make wine. Tony is quite an expert wine-maker and sent me out to gather the harvest. For that reason I was sent out in April to pick dandelions.

The farmer at Hill Farm had his sheep sheared; they looked naked against their unshorn lambs but they must have felt a good deal lighter without their heavy coats. Regardless of the ewes' anxious calls I was the centre of the lambs' inquisitiveness as I walked across the field. They approached, curious to discover what I was doing. The adults gazed at me intently until I reached the gate.

Our rhododendrons were draped in bindweed (*Convolvulus*). The white satin booms were still unfurled, rolled up like lace parasols. A bee buzzed over my head and made for the spotted bloom of a foxglove. She alighted on the lower lip and wriggled her way in as far as possible. The bee (*Bombus lapidarious*) has fat furry black shoulders and a red bottom: she collects the pollen and tucks it into tiny pollen baskets on her hind legs.

The flower borders attract the dragonflies of one particular genus. The sparkle and shimmer of their wings in the sunlight caught my eye. Then I noticed the body of one of them, fat and dullish brown but with a row of bright yellow dots on either side of the abdomen. I could only get one single photograph. My field guide informed me that it was a female broad-bodied *Libellula depressa*. Depressa is a strange name for such a vibrant creature.

The solitary plant of feverfew that my friend Barbara gave me last year had seeded itself. The gravel drive now sports many attractive tiny yellow fern-like leaves. As this plant is regarded as lucky, we were supposedly in for a good year.

The meadow has a long flowering species of clover that I planted especially for the bees, a variety named *Trifolium*. The long head is a beautiful red. There was a lot of wild clover flowering in the sanctuary including the yellowish white sulphur clover (*Trifolium ochroleucum*) but I have as yet to find a lucky four-leafed one.

At ten-fifteen that night, One-Sided-Flash streaked in amidst the noises of the cubs in the background. I peered intently, my eyes searching the undergrowth for the slightest movement. I could hear bickering as the cubs fought among themselves. The bright lights did not seem to bother them one

bit. The lure of the food was so strong that the two vixens, Jess and One-Sided-Flash, repeatedly crossed the well-lit area.

David MacDonald, a zoologist at Oxford and a prominent author of books on natural history was, at my invitation, visiting the following night. He had spent a good deal of time studying the fox population in the woods. We positioned ourselves in two easy chairs in order to watch the cubs. The first arrival was One-Sided-Flash, followed by two small shadows. David was very excited and kept gasping: "I don't believe it". "Look!" he said. I looked until my eyes began to ache, uncertain of what I was supposed to be looking at. I was reluctant to ask questions for fear of frightening the cubs away. "Very odd," David exclaimed, "I have only seen this once in my observations and that was in this very garden many years ago".

Finally, I asked what I was supposed to be looking at. "White spotting on the legs," David explained. "Ten years ago there were four vixens in the area using this garden, three of which had unusual white markings on the legs — markings which I have never seen again until today. Very odd," he repeated.

David and I watched until eleven–thirty pm, captivated. As David reluctantly got up to leave he told me that he thought they were probably descendants from the same family that he had first seen those ten years ago, and that Crank-Handle might have met with an accident some time back.

Another night, Bob, Tony, Michelle, David and myself were all sitting in full view of the window with the arc lights full on. One-Sided-Flash had no hesitation about coming in for the food, which I had made as appetising as possible. I knew that the foxes had accepted me — but would they permit several persons to watch them? The doors were closed and our lounge lights were off, leaving us seated in complete darkness. The foxes could not see us or get our scent.

We had decided against whispered conversation and were totally surprised when One-Sided-Flash, with a cub in tow, gave a soft mewing noise and stepped into the light. And there they were: three other small shadows with soft white fronts just out of reach of the arc light. With the night scope I picked out the identifying marks of each cub. The first had an exceptionally long tail with a white tip, the second a shorter tail without a tail tag, and the third cub's tail ended with a black tip.

The fox family stayed in the half-light while the vixen came to collect food. The cubs shuffled about in the undergrowth. From where we were we could hear the high-pitched yaps of eager anticipation as she returned to them. Several times she made a visit to the far end of the rhododendrons with food, but we were unable to detect if there were any more cubs. The

youngsters, who were about eight to ten weeks old, were just showing through the dark brown of babyhood the red colour that they would acquire when adults. The cub with the black tip on her tail was more nervous than the other two, and sat among the shrubs whining softly for food, hidden from our view behind the dense cover.

The weather was appalling one evening; it was like walking through a quagmire while setting up the lamps and flash lights on the lawn in preparation for the foxes coming to feed. Luckily, the short storm faded away quickly. The foxes arrived, a little bedraggled with coats wet through. They left dainty wet paw marks on the patio tiles. Like Bracken, they flexed their muscles and shook the water from their bodies as effectively as in a salad dryer. The gurgle of the down water pipes upset them a little until they became accustomed to the noise. Already at the food, Crank-Handle chased Jacob away. Their individual traits were interesting and fun to watch. Crank-Handle was a real glutton and adventurous; if any mishap was to befall any of them I was sure that he would be the victim.

It was a night of disruption. Soon after the foxes' exuberant appearance, the tungsten lamp — insecure on the soaking wet lawn — suddenly crashed to the ground. To Tony's consternation I dashed out thoughtlessly and, picking up the lamp from the sodden ground, rammed it back into the soil with wet hands. I saw five pairs of glowing eyes lit up by the lamp, bobbing about in the undergrowth as if remote from their bodies. The tension evoked was soon forgotten and five minutes later all the cubs were back, eating on the lawn.

In an effort to persuade the fox families to stay and feed, rather than grabbing the food and rushing off, the following night I minced up the meat and pressed it lightly into the damp ground. Three cubs arrived simultaneously, bouncing in, squabbling noisily. They stayed to feed and played for at least half an hour before the vixen appeared. I had no doubt that she had been watching the cubs from the cover of the bushes, and should there have been any danger two or three warning barks would have brought them to her side.

The vixen did not attempt to carry the small pieces of meat away but stood beside it and made a soft yittering sound. I caught a glimpse of an ear highlighted by the lamps, but this hastily withdrew and I couldn't be certain that another cub was present. It is a long time before a tiny cub finally ventured out, the runt of the litter. She ran up to the vixen who licked her upturned face, and then both animals glided quietly into the undergrowth, leaving the four larger cubs to fend for themselves.

One-Sided-Flash had five cubs: the smallest cub we named Darky; the

largest cub with a white-tipped tail named Flag; the cub with black-tipped tail named Goliath; the cub without a tag named Jacob and Crank-Handle.

When I first decided on my wildlife garden I did not realise how involved and dedicated I was to become. True, I am lucky enough to live on the edge of woodland, but my garden for wildlife is the bonus zone. I expected to entice a few species in, but to have goshawks, woodpeckers, tree creepers and nuthatches all nesting in the sanctuary is more than I ever desired.

In an overgrown part of the wood I found three oak saplings about four inches high, crowded together in a small hollow. I removed two and replanted them at the edge of the glen where I hoped they would become fine trees. The ivy in the sanctuary climbs the oak with sturdy anchors. Contrary to the popular belief that ivy kills the tree, its strong stems as thick as your arm can actually help support a frail tree. However, when mature, ivy can also make the tree susceptible to falling in a strong wind. Ivy provides both food and shelter for much of the wildlife. It is a meal for the caterpillars of the holly blue butterfly and swallow tail moth. The bird population eats the poisonous berries. When the ivy is in flower, then it is the turn of the insects, wasps, flies and crane flies to feed on the nectar.

The rhododendron is not recommended as a conservation plant, but ours supports a North American species of leafhopper, a marvellous green and red colour. Members of this species live on the undersides of the tough shiny leaves. The bees adore the flowers; we have counted at least five different varieties, the bumblebees being the most prolific. Dragonflies launch their attacks from the topmost branches over the creepy-crawlies who find an important food source on the floor. In the depths of the rhododendrons I once discovered an empty chaffinch nest.

Tony came to show me an insect cupped in his hands. The creature was quite small. The fore wings were mottled black and white and had a metallic green sheen. The hind wings and abdomen were scarlet with black markings. We searched for it in our butterfly book but could not find one to match its description. We thumbed through the moth section, with more luck. It was a day-flying scarlet tiger moth, which feeds on hemp agrimony and valerian — another reason not to pull up the prolific valerian.

At dusk, a moth flying around the porch lamp intrigued me. What a beauty. It looked very similar to the muslin moth. Could it be a male of the same species? The wings were like gauze: white with startling black spots around the edges. The large spots became small freckles as they neared the centre of the wing. The creature's head was soft and silky with fine fluffy hair, and on it there were six black conspicuous spots arranged in two

converging rows of three. The body was barred grey and white. Once again we could not find a description of the moth in any of our books, so I took several photographs, intending to send one to the Natural History Museum in London and another to Dr John Campbell, Woodstock Museum, Oxford for identification.

One day ended with a fantastic thunderstorm, sheet lightning accompanied by loud claps of thunder that rolled menacingly around the woods. The following morning I discovered lots of moths in the entrance porch. One was particularly beautiful, with fluffy white hair covering its head. The white wings were flecked with black polka dots. I tried to pick it up and it fluttered to the floor, feigning death. It was the white ermine moth (what an appropriate name). I took five photographs before placing the moth in a shrub. I also photographed two other moths, the large emerald and the green oak tortrix moth. There are many moths on the wing throughout June, July and August. Having kept a record of butterflies on the reserve, I decided to further my conservation work by carrying out a survey of the moth population.

The Council's mechanical trimmer had been busy all day. The long arm ripped through the hedgerow and although it made the road seem wider and driving safer, it is sad to see so much vegetation disappear. The hedgerow foxgloves fell victim to the greedy and undiscriminating machine, which, like a giant monster with an insatiable appetite, devoured its way along the road.

A huge variety of wildflowers can be seen along the railway embankment: dog roses, honeysuckle and trailing creepers of bryony scramble over shrubs. Along the gravel footpath we found bright yellow bird's-foot trefoil, pink clover and Oxford ragwort. To be able to see the plants clearly without trespassing a pair of binoculars were needed. A great many grass snakes can be seen sunning themselves on the warm gravel in the suns rays. The chalky bank is riddled with holes and the rabbit population heavily grazes the grass. Foxes sometimes enlarge the burrows into earths for their young, and there is also a larger entrance, as a badger very wisely resides there. There is no human traffic — it is too overgrown and on private property. That particular badger sett has food on the doorstep and a stream nearby, all mod cons.

On our way back to the hotel Tony and I had difficulty climbing through the white-flowered brambles and bracken. Tony lifted the long trailing arm of the bramble (complete with bees) above his head and forgot that I was walking behind him. We came to a clearing where we had seen a doe and her

fawn the previous year, but we were not so lucky that time.

The muddy paths the following morning gave clear indication of the volume of traffic during the night. The foxes were the most mobile; their footprints were everywhere. They were also the most vocal, with the exception of the owl population. Their blood-curdling screams never fail to send shivers up my spine. At Eeyore's Place, I found scattered tracks of both roe and muntjac deer without any real direction.

After a tedious climb, I reached the ridge. Tits flew ahead of me, flitting from bush to branch and back again. I studied an army of ants. Carrying leaves aloft — probably to their nest — they look like a file of windsurfers.

Day after day the fine weather continued and the woodlands were full of buzzing flies. In the shallows of the stream, legless water babies basked in the warmth. Originating from round black blobs with long tails, the tadpoles would soon turn into frogs. I netted a few to examine them more closely under the microscope. The uniform black look was lost, the round blobs had eyes and they were mottled brown like toads. My second dip into the water with the net produced an assortment of life, including a caddis fly larva.

Later I visited the garden centre and purchased some more wildflower seeds for conservation purposes, including: yellow horned-poppy (*Glaucium flavum*), corn cockle (*Agrostemma githago*), greater knapweed (*Centaurea scabiosa*), common red poppy (*Papaver rhoeas*) and harebell (*Campanula rotundifolia*). I also purchased wildflower meadow mixture and damp meadow mixture, ensuring that the flower varieties were native to Britain.

In the lazy heat of the afternoon I lay on the sweet-smelling grass by the

rhododendrons, then in full flower. A woodpigeon alighted nearby. I turned my head slowly to see the soft blue-grey of his back and his white necklace and wing bars. I noted how strong his beak appeared close up. There was a rush of air overhead as a great flock of rooks fly in from the wood, calling harshly to each other. Among them I could also hear the cries of a pair of jackdaws. The woodpigeon was up and away, the air full of the beat of his wings as he took off hurriedly and noisily with a startled cry. A swift dark form arrowed through the trees and seconds later a goshawk settled ten feet away in an oak. I remained quite still and the bird ignored me, her yellow orbs fiercely searching the wood.

It was the first of my moth evenings and the lamps were out in the meadow, the vegetable plot, the copse and at Eeyore's Place. They were placed on a white sheet to attract the moths. Also on the sheet were empty egg cartons, which the moths alighted on. That evening there were at least six people at each station with identification books. We had the pleasure of two experts, whose knowledge was greatly appreciated. The moth whose type could not be determined some evenings previous was identified as a leopard moth.

The moth evening was very successful. Our list contained over 100 names from the event. One moth that I found could not be identified, as it was not listed in any of our books. Although we thought at first it was an entirely new species, it was finally determined to be a member of the owlet family.

Chapter 13
July Fox Cubs and Feathers

Nature has provided me with many beautiful views, lots of rare birds and a seething metropolis of insects. My first sighting of the gold crest held me enraptured: a tiny crowned princess perched on a larch wearing robes of green.

Among the shrubs grow a rather lovely specimen of greater bindweed (*Convolvulus*). Two pure white buds and one open flower were startling in their whiteness. I took a photograph and then sat down to draw them in case the photograph did not turn out. Within seconds, a striking long horn yellow black-banded beetle alighted on the open flower. Down below, a violet ground beetle was actively scurrying about the leaf litter. They are quick moving predators, eating garden pests such as leather jackets, slugs and wireworms. The violet ground beetle is named for the violet sheen on its wing cases. Different varieties of ground beetle are found in various habitats ranging from sandy soil to the marshy area of Eeyore's Place. The larvae spend their lives in the darkness of the leaf litter and like their parents are carnivores.

Many of the grass verges were spectacular that year. The local Council had done us proud, taking an interest in conservation and green issues. The Department of Transport contractors must surely have planted the many wild flowers. I could see masses of vivid blue, which I thought at first belonged to the cornflowers. To my surprise I found that the blooms were those of the wild chicory. They looked splendid alongside ox-eye daisies and red field poppies. Nearer the road I came across Oxford ragwort (*Senecio squalidus*). A cinnabar

moth was depositing eggs on the leaves. The plant had very small caterpillars of the same species adorning it. Without being too observant I also saw Essex skippers and brown Argus butterflies. I discovered the odd wavering patch of feverfew (*Chrysanthemum parthenium*), foliage golden as the sunlight. Far off against the skyline I could see the gleaming spires of the city, and away to the east a bunch of red cows grazing in the patchwork of farm fields. A sighing breeze swayed the whiskered ears of corn.

Wild honeysuckle (*Lonicera periclymenum*) needs little introduction, for its fragrance and beauty must be well known. The colour varies from plant to plant and those near the stream are pale in colour, glowing a soft creamy-white in the evening sun. The elongated tube is deeply cleft and has the appearance of four or five petals; the stamens number five and protrude from the mouth. Each blossom secretes a quantity of honey, which at night attracts the larger moths, and so the plants become fertilized. My hide was erected beneath its cascading branches and from this heavenly perfumed habitat I would be able to film to my heart's content. That night I particularly wanted to observe the moth population, but ended up watching nocturnal creatures.

The owl was abroad almost as soon as the sun went down, and I heard his hooting faintly from within the sanctuary. The sound quavered longingly on the air, a lovely warbling note. I went to my hide at ten–thirty in the company of two pipistrelle bats hawking for insects above the pool.

The following evening was glorious with the heavenly scent of Lily Maria (*Lilium regale*) and two pollen free lilies: Aphrodite and Sphinx. The night scents of stock, tobacco plant, and heliotrope were so strong that they wafted through my window. I found myself breathing faster to enjoy the fragrance more.

One of the cubs had been injured. When they came in for food I noticed that one of them had lost most of its tail, leaving him with what looked like a pom-pom. We re-named him Powder Puff. It is a real handicap for this to be missing. Apart from its value as a nose warmer when the fox is sleeping, it is also used as a means of communication. Now that the cub could not lash his tail in a gesture of submissiveness he was giving tiny whimpers as he approached the food. Already eating, Darky pulled back her lips and opened her mouth. In contrast, the injured cub rolled over onto his back in submission with his legs in the air. As the tail was so short I could not tell whether the victim was Goliath or one of the others.

I was busy sketching two of the foxes when I observed that the page had a warm glow about it. Surprised, I raised my head to see one of the most

beautiful sunsets I have ever witnessed: scarves of dark colour were thrown across the horizon. First there was a rosy glow, which deepened to an intense magenta. The clouds were coloured a smoky-pink, trailing along the gold-yellow sky. The trees were etched black against the sunset until the colours slowly faded and the whole scene turned blue-grey as the night arrived.

The cubs jostled in at seven o'clock the following evening. As they arrived I counted them in - one, two, three, four, five, six. Had I miscounted? I started again. I could identify all six of them: Crank-Handle, Darky, Goliath, Jacob, Powder Puff and Flag.

So the entry I had previously made in my diary when I wrote about an injured cub was wrong and Powder Puff was either a stranger belonging to another family, or else another of One-Sided-Flash's cubs. At twelve–thirty we heard gunshots in the woods and went to bed concerned about the foxes, deer and badgers.

I received a call one morning from Oxford Scientific Films, in response to my letter telling them about my strange foxes. They were very interested in making detailed observations and wished to make an appointment to film once again.

We were positioned under a large holly whose cascading branches formed a green cave. A camera had been set up outside, focused on a piece of meat, to which I hoped a fox would be attracted. The sky reflected in the pool was a deep blue and I could hear water trickling over the stones of the stream at the boundary. There were two pink water lilies resting on the surface of the pool and dwarf bamboos striped pink and green grew around the edges with their feet just in the water. The ragged robin flaunted pink spidery blooms — another success for the sanctuary. I sat with Tony on a seat he had made, our field of vision confined to certain areas, and caught glimpses of the meadow covered in tiny blue flowers. We could see a selection of shrub roses, parts of the shrub walk and the orchard. Just out of my view, I knew that the orchard was full of fruit. Unfortunately, wasps had attacked the plums, and worse still the deer had sampled most of the apples.

After a while a shadowy shape moved along the hedgerow, and I could hear soft footfalls and the crackle of twigs. Apparently unsuspicious, Goliath came slowly towards the meat until he was only four or five feet away. Either I moved or he scented danger, for his head went up and he stood motionless but out of range of my camera. Then he ran swiftly back into the woods and was concealed in the vegetation.

Having lost that opportunity, I followed Goliath with my camera still on its tripod, flung over my shoulder. I lost him rapidly but, seeing a squirrel, I took his photograph instead. Stung, torn and bedraggled, I felt a little

embarrassed at the sudden appearance of Tim, who as an ornithologist is very interested in the bird population. We had a quick wander around the sanctuary looking for old bird nests. It was Tim who startled Goliath lying up in the vegetation: for a split second a head was raised from the bracken, then the fox belted off in overdrive and my second chance for a photograph was lost.

In the late afternoon I came across four half-grown fox cubs near the farm. It made a lovely picture, the dark mass of trees on one side casting inky pools of shade, and the farm on the other, deep in corn coloured amber by the sun. The cubs stood motionless in a peculiar crouching position, indicating that they could scent danger. The cubs fled suddenly, presumably having caught my scent.

The cornfield was full of rustlings and I was immediately treated to the sight of a tiny field mouse sitting on the fringe eating a kernel of the grain, providing a feast for the wild creatures. I strolled along the boundary and heard the low clucking of a female pheasant just before she appeared out of the corn. Unlike the male, her wings are a mixture of distinctive browns. A concentration of rooks and starlings took off only to descend on the shorn wheat fields opposite. Shining blue-black, the birds foraged among the stubble. Of all the birds that have nested in the sanctuary our favourite is the gold

crest. She chose to nest right in the hotel car park in a very large larch tree. Although conifers can be boring they have their uses. The gold crest nest is unbelievably delicate, constructed from cobwebs, lichens and mosses, all of which are plentiful in the sanctuary. The nest is lined with masses of feathers. Slung beneath a rather low solid bough it hangs from a cobweb structure like a hammock.

The sanctuary was full of young birds, all begging food from their parents. They stay hunched up beneath the shelter of the rhododendrons, or call from the protection of the bushes in the shrub walk.

At ten o'clock, Bob and Sue arrived to watch the foxes. The lights outside were on, although they were not needed. Six cubs appeared together and we watched carefully, counting the cubs as they appeared. We reached a total of eleven — one more than we had previously counted — and we realised that Jess must have produced five cubs. Bob pointed out one cub with a very long tail, kinked in the middle. It was all very confusing: we decided that six of the cubs must belong to Jess.

Jess's cubs were still unnamed and I felt we had to give them names as soon as possible for identification purposes. At about sixteen weeks old, they had chunky bodies, red fur and black stockings, their ears were pointed and their tails slightly thicker and longer. If they were not too hungry, they sat down in front of my camera until the sound of the others playing spurred them on again.

It was a cloudy and starless sky the following night, so the new lamp Tony had bought would come in useful. Tony stayed up to watch with me that night. As soon as it got dark enough, he noticed a movement below us under the patio doors. A baby field mouse, no bigger than a harvest mouse, slipped out to partake of some birdseed I had put out for that purpose.

Into the picture came a fine-looking fox, very young — a newcomer. The fox had a granny-knot tail twisted and coiled in such a way that there was no beginning and no end. I took a single photograph using the flash, hoping for a superb photograph to show the experts (who were beginning to doubt me). The cub was accompanied by four of Jess's family, therefore I assumed that it was one of hers. We named Jess's cubs: Tansy, Ginger, Rowan, Powder Puff, Jasper and Sarah.

I was glad to be up so early, especially when three deer arrived on our lawn to delight me with their presence. They were not the usual muntjacs, neither were they spotted like roe deer. They were fallow deer, a reddish-brown with a triangular white flash under their tails. Bracken appeared from nowhere

and startled them. The deer crashed off. I reprimanded the dog, who continued to follow me on my morning rounds.

I checked the badger sett at Hazel Copse and the one at Brockmere. I saw two cubs up on the ridge, almost as big as their parents now, and in much better condition. They should have been, considering the amount of food they got through. I had started putting out food at only three-day intervals, to ensure that they hunted for themselves. My outlook of what makes a sanctuary is all encompassing, and that day I studied a ruby-tailed wasp, a predator.

Before dawn is a marvellous time to be up and about, for in the solitude of my own company I hear and see things that I would otherwise miss. I watched the sun rise, its dawning accompanied by the exuberance of the cubs as they played a game of chase around the pool. On those warm still mornings, all kinds of perfume evade the sanctuary. In a dark corner, *Philadelphus* stops people in their tracks as they try to discover where the provocative perfume is coming from. The spruces add a pungent fragrance.

It was mid-morning when I spotted Flag. He was still abroad, prowling about on his own. I walked stealthily towards him to see how close I could get. I was conspicuous, dressed in white. At three yards away I stopped and looked him in the eyes and he stared back before slowly walking away. I felt elated for I was surely accepted by One-Sided-Flash's offspring. At Eeyore's Place I observed three foxes playing together. This play takes the form of chasing, leaping and standing on their hind legs; sooty paws resting on each other's shoulders. They were Darky, Crank-Handle and Flag — no sign of Goliath or Jacob. I assumed that they were foraging on their own somewhere.

I received a visit from Bob who introduced his friend John, whose hobby is wildlife photography. He asked me if I would mind if he came to film at the Hotel. We set up cameras and wait for the cubs to make their entry. After sitting for at least two hours without a sign of them, John came to the conclusion that they must be able to scent him. He had set up his own camera on the lawn and in doing so had left his scent there. After another hour had gone by, Bob and John decided to leave, but before they went they asked if they could return at the same time the following week. John suggested that the next time, he would leave the setting up of his equipment to me. Soon after they left, the cubs came bouncing in.

The dawn arrived rare and beautiful with a faint mist hanging in the air. Everything was softened in a slight haze. Just across the glen was the woodcutters yard. A lazy spiral of blue smoke drifted up between the hedges and the pink spires of the rosebay willow herb, which thrust up through the wiry entanglements of convolvulus and bryony. I watched the cubs at play:

poetry in motion. They were incapable of awkward movement, leaping and chasing each other through the undergrowth. There is romance in these woods for anyone with imagination, for the wandering gypsies and the local hunt, who poached and hunted in the past, used them regularly. Matthew Arnold, who wrote *The Scholar Gypsy*, frequented these woods and grew to love the area.

Oxford Scientific Films arrived at eleven-thirty am, after a rather long journey. I hoped that they would find it worth their while and that the weather would remain fine, but no amount of planning can guarantee success. At six pm, just before they were due to come back to film, I received a telephone call. Would I mind if they were to bring Granada TV crew along with them? Finally there were six of them and all our family watching the events. Their TV cameras were enormous and when they switched on the illuminations they had erected it was brighter than daylight and I wondered how the cubs would react.

The members of One-Sided-Flash's family ignored the lights, coming straight in for the food, and a good two hours was spent filming a programme on foxes for the television.

Tony took me out to dinner as a treat. It was a mild night: clear and starry and there was nearly a full moon. In my hurry, I forgot to leave the food out for the foxes, and on our return at eleven we found a note on the reception desk saying:

'May, called to have a chat about the weekend, but found you were out. Have checked the sett and it's ok. We stayed to watch your foxes and David gave us the scraps to feed them with. We watched from the jacuzzi window and saw three cubs including the tail-less one. Sorry you were both out. See you soon, thanks for the loan of your foxes. Love Sue and Bob.'

I felt sad that I had missed them. But as I stuffed the note into my pocket, I could see them walking towards me. Tony replaced the food supply, and we spent a further hour watching the foxes as they returned.

We were puzzled about the tail-less one and thought that Bob and Sue had seen Powder Puff. However, the first two foxes that materialised were Goliath and Flag — both with normal tails. Soon after, a movement in the shrubbery caught my eye and I spotted Crank-Handle, but Bob and Sue insisted it was not the same animal as they had seen. The colour on their fox was much darker, they said. To our left, another cub came in and I gasped in amazement. It was the twin of Crank-Handle, the only difference being that there was no overlay of darker hairs on its tail. Immediately following came a fox without a tail, very handsome otherwise, and in a lovely coat. I only

recognised three cubs as belonging to One-Sided-Flash. The remaining two must have been part of Jess's family. Altogether, we had six cubs whose mother was One-Sided-Flash and to our knowledge six cubs that belonged to Jess.

Bob and Sue had to leave, but they promised to come again as soon as possible. I stayed up to take photographs of the deformed cubs: I managed to photograph Crank-Handle and his twin and also normal-tailed Goliath and Flag.

Crank-Handle and his twin both developed a harsh hacking cough and once a fit of coughing came on the poor creatures were unable to move. With necks outstretched and bodies hunched, they seemed to spend much of their time together. The very first time I heard them coughing I thought it was a case of greedy foxes choking on the food. Or was it possible that they had a disease similar to kennel cough in young puppies? Worried about their condition, I decided to keep a watch on those two. The fact that they were from two different families was very odd. The cubs were developing other side effects and I decided that it would be advisable to inform the RSPCA.

The luxuriant growth of the valerian was threatening to obliterate the paths. It grows in every crevice and crack available to it. The large area at the front of the hotel is of gravel, kinder to the eye than grey oppressive concrete or tarmac, and in this environment yellow-horned poppies thrive alongside herb robert and groundsel. I refuse to pull out anything that I am not sure of and by the time the various plants came into flower and brightened up the car park I found that they have seeded themselves everywhere.

The new clematis (*C orientalis*) from Tibet has waxy petals as thick as orange peel. They begin a pale green colour and gradually turn yellow, ending up a startling orange. The foliage is very fern like. We have only one plant of this variety growing on the west wall overlooking the patio area, where the foxes and badgers partake of the food. This luxuriant plant liberally covers itself in flowers. Also growing in the border is a plant by the name of *Anaphalis yedoensis* which flowers in the autumn. The unusual paper-like silver and ivory blossoms cover the tops of the stems and are particularly attractive to soldier and longhorn beetles.

The meadow had been harvested twice that year and it was surprising how much fodder it had produced. We gave six large bags of sweet smelling grass to a friend for her Shetland ponies.

A large nest of mature ants had just taken to the wing. I watched the transparent winged black insects climb in hordes up the twiggy stems of my dwarf elm. They took to the air simultaneously, much to the enjoyment of the dragonflies that were swooping and diving like warplanes on their victims.

I chose a spot by the stream where the golden-yellow flags and water iris were in flower and sat down. A dragonfly alighted on the rusty-red leaf of a water lily and rested, his wings of gossamer outstretched to the sun. Such is the attraction of the pool that I found it difficult to tear myself away. Around the edge were many delicate bodied damselflies of truly amazing colours. There were deep reds and greens but my favourite is an iridescent blue with a light on the tail.

July is the time to look for feathers, as the birds are in moult. I found three separate jay feathers in the same area: all were the beautiful electric-blue and black-barred feathers from the wings. I saw the first two easily as the bright blue colour caught my eye but the last one looked like the light grey under-feather of a woodpigeon until I turned it over. Two were from the right-hand wing of the bird and the other from the left. I decided to keep them to draw and paint. Among my many finds I discovered the barred black and white feather of a great spotted woodpecker and the shot-silk blue-green feather of a magpie.

The gall wasp had been busy on the oak trees, the hawthorn and the roses. Each different species of wasp injects their eggs into the host plant. When the larvae hatch the result is that the buds become deformed. I prised open an oak gall; inside I found a grub with a transparent body. Those were not the only galls, on the roses I found robins pincushion, looking like a strange red sea anemone. When I touched it, it felt very much like moss. The gall insects are rather pretty little insects with blue or green iridescent bodies.

It was interesting to see the sand digger wasp excavating a burrow in the butterfly border. The wasp is quite large but slender with a long chestnut body. The burrow would contain a paralysed caterpillar and the wasp would lay an egg on it then seal the burrow where her larvae would develop in safety. Among the plants is an ichneumon wasp, a parasite laying eggs on the bodies of caterpillars. All of the creatures are part of the ecology of the sanctuary. I have provided this habitat where all are invited to take up residence and make this their home. The hedgerows sing not with birds at this time of the year, their voices are muted, but with the murmur of bees, grasshoppers, crickets and other insects.

I placed a white plastic sheet on the ground in order to discover what creatures were sheltering in the shrub walk. A quick shake of the bushes and a whole range of spiders, flower beetles, leafhoppers, weevils and bugs cascaded from the cover. A small glossy black weevil with a distinctive long snout was the first to be dislodged, quickly followed by a nut weevil also with a long snout but brown in colour and only 5 mm long. A glorious red beetle was next to catch my eye, a pest 10 mm in length similar to the lily beetle.

To my delight, the black-headed cardinal beetle scurried into view. This creature can easily be confused with the lily beetle as it is the same colour; its larger size helps identification.

Among a host of tiny flower bugs was a large bush cricket. It is instantly recognizable by the large egg-laying organ, shaped like a scimitar. Bush crickets are the favourite food of some ground feeding birds and small rodents. They are mostly green in colour and escape danger by leaping a few feet. Another shake of the bush, and spiders of all shapes and sizes fell onto the sheet, tiny yellow or pale green bodies. In late summer long-legged creatures can be seen among the grasses and walking across bare soil. They are called harvestmen. Unlike spiders, to which they are related, they do not spin webs. They have a life span of four to five months.

I came across a dead tree, its many holes made by the woodpeckers and blue tits causing water to seep in. Eventually the tree had succumbed to wet rot, becoming the home of stag beetles. The air was full of thunder flies that day, which drove us mad as they continually landed on our faces. They were blown in from the farmer's fields down the hill as he harvested his corn.

Chapter 14
Flora and Fauna of August

Flag appeared on the lawn in the middle of the afternoon, gazing in my direction. At the hide, I placed the food within focus of my viewfinder. There wasn't time to be accurate about the job, as I wanted to persuade Flag to come close before he left the area to roam the wood. Safe inside my canvas room, I waited only a few minutes before he appeared and proceeded to polish off the food. He filled the screen and I adjusted my lens until I had the perfect shot. I pressed the button and the motor drive whirred like an engine at full throttle. Flag looked towards me but did not run away.

A wasp made a dive towards me and in the confines of my hide I panicked and struck out at it. To my surprise, Flag came up to the source of the commotion, standing near the opening of the hide which was partly zipped together. I took a breath and slowly — oh so slowly — reached out my hand towards his red coat. Without any pressure I stroked his neck, bursting with joy, until he left.

We had a sharp thunderstorm. Rain bucketed down, lightning zigzagged across the leaden sky followed by a prolonged rumble of thunder in the distance, and I heard continual lashing of rain in the undergrowth. I sat in our lounge, comfortable and dry, but the foxes were no fools. During the whole evening I saw only one of Jess's cubs who ventured out but briefly before disappearing for the rest of the night.

The badgers don't mind the rain — it makes worming a lot easier. The fox cubs lost their supper to the badgers that night who happily scoffed the

lot with a good deal of noise. I watched the badgers searching the lawns for worms, sucking them up like spaghetti. It was four–thirty and would soon be light. The storm was abating but there was still a high wind. The badger family moved off, they liked to be safely underground by dawn.

The body of a three-quarters-grown fox cub lay at the side of the road, hit by a car. Death on the road was rife that month. Another victim lay on the grass verge close to the hotel; it was one of Brockmere's badgers, lifeless but still warm. I filled in one of my casualty forms with the relevant details.

Over the ground were prints of a fox, smaller and neater than Bracken's footprints. I spotted the owner loping along the ride; it was Darky. She really was beautifully furred, with dark chestnut-brown and black teardrops on a tawny background, four black stockings and a black-tipped tail. They were perhaps not quite the correct markings for a fox, but to my eye perfection.

The young field mouse that I had seen in June had a very short life. One night, Goliath came in as usual but instead of making for the food, he stood quietly on the lawn letting me take photographs. I saw the velvety ears move forward and seconds later he ran noiselessly across the lawn, scooping up the mouse as he went.

Two roe deer stood together at the woodland's edge with their noble heads raised and antlers catching the early morning sun. The last I saw of them, they were treading silently along the ride bound for the thick cover of the trees.

The sun was a burning disc, and as it sank lower, we found driving more difficult. While we were negotiating the hill, the sun on the crest burned directly into our eyes and we had to raise our heads to avoid the glare. Then one of those memorable incidents occurred. A flock of tits bathed in an apricot glow flew along the hedgerow ahead of us, followed by a sparrow hawk. We could hear the jays scolding. Agitated and upset by the sparrow hawk's disturbance, they continued to shout abuse throughout the feathered drama. Although the day was far from ending, a single star glowed ghost-like in the sky.

Since August is not such a busy month for gardeners, I decided to prolong the flowering season of my buddleias by deadheading them. It was well worth the effort to encourage the butterflies to continue their visits. After the first crop of purple flowers had died down, I pruned them to get a second flowering. In the winter I cut them hard back and by the following spring, the shrubs had become dense arching sprays of vegetation. We grow *Buddleia alternifolia*, a cascading bush of mauve flowers, *Buddleia globosa*, yellow ball-shaped flowers in November, and *Buddleia davidii*, my favourite, with cascades of mauve spires.

When I arrived at the shrubs I found them covered in small tortoiseshells, peacocks and red admiral butterflies. Purely by chance I saw the picotee-edged wings of a comma butterfly about to open. I quickly adjusted the macro-lens on the camera. The glamorous flowers of the woody nightshade had opened, purple bells with yellow centres climbing stealthily among the rhododendrons. Later in the year, luscious red berries would give us pleasure.

The mauve flowers of the garden mint proved to be magnetic, bent double by the weight of the bumblebees. Everywhere I looked, on stonecrop (sedum), and on golden rod, on powder asters and on dianthus, there were butterflies, bees and hoverflies. The urge to photograph the metallic armour of the flies was strong and although I was short of film for my foxes I felt that it could not be considered wasteful when I discovered a wasp-like insect shaped like a giant ant, with black and white stripes. The air was full of the continuous droning of woodland grasshoppers, a sure sign that there were shrews in the area. A gauzy veil of gnats flying in the air close to the oak trees settled on my bare arms.

Once started, the work of clearing the overgrown borders gathered momentum. The herbaceous borders had to wait until autumn, but I began work on the two heather beds containing the winter-flowering heather (*Erica carnea*) varieties. If left to spread, the individual plants would soon form a solid carpet. The fallen leaves of the previous autumn had formed a thick congested pile entangled in the brilliant green foliage.

The thistles had lost their mauve-blue heads and were covered in a feathery down, enticing the goldfinches in from the motorway. Sunlight silvered the balls of thistledown on the tall rods of the rosebay willow herb.

The herb garden was at its best: lemon mint, peppermint, apple mint, basil, tarragon and rosemary are all lovely at that time of the year. Near the rockery we had created a chamomile lawn. I loved to walk barefoot on its silvery foliage, crushing it until its perfume pervades the air. Rabbits sometimes came to nibble the herbs.

I could not locate the Brockmere badgers. Something had caused them to move from their sett. I found evidence of badgers digging at the old briar sett. Newly dug earth was piled red-brown over the fronds of the bracken. Perhaps the Brockmere badgers had moved to that vicinity.

The upper-class cherry trees were no longer crystal chandeliers: they had come down in the world. The fresh green leaves were now a lot darker and red cherries festooned the branches in pairs like gypsy earrings. Here and there, former glowing red cherries had only blackened stones hanging from thin green stalks. The birds had been attracted to them already.

The two conifers (*Conifer stewartii*) had grown so tall that I wondered whether I could tie the tip of each down to the other to form an archway. A bird's nest was hidden among the branches. Now that the nesting season was over, I removed the nest to examine the materials the bird had used, after which I replaced it. Maybe a dormouse would occupy it for the winter season.

I set off down the slope of our lawn in the shadow of the hedge, and crossed a dilapidated wooden stile into the plantation. The area is a mixture of plantings and is broken up into sections by three straight rides. The only sound I could hear was the scrabbling of a rabbit as it scuttled away into the undergrowth. Darkness was falling and five bats on umbrella wings were swooping among the trees, tasting the insect life. Discarded wings from their meal floated slowly to the earth, lit by the hotel.

I slid beneath the barbed-wire fence into the dark ride just as a great brown owl came skimming around the corner and circled over the bracken. Seconds later, she plunged earthwards and remained down out of sight in the cover. Unlike the bats, the tawny owl eats larger prey and hunts for rodents. I have often seen both hawks and owls hunting along the rides where field mice and voles are plentiful, and where I have often flushed a pheasant as I wandered. Minutes later on the outskirts of Brockmere, I came across an old ivy-covered stump scoured with furrows made by generations of badgers sharpening their claws. I spent many a fascinating hour watching the activities of the badger cubs at this strange scratching post.

John arrived with a superb signed photograph of a badger for me, and he asked if he could watch the foxes that night. We tried filming with the windows open but we had no success. The cubs got scent of John and only circled in the background out of range of his flash.

I awoke to a dismal day, with a heavy mist hanging over the woods. Visibility was so poor I could only just make out the faint outline of the trees. The mist was heavier about halfway down the trunks so that the trees rose black from the blue haze. There was not a hope of spotting a bird, or anything else for that matter. But by nine-thirty the mist was rising, and a warm sun bathed the red-gold leaves of the bird cherries and turned the bracken blond. The city spires gleamed blond-khaki in the distance. I had seldom seen them looking so beautiful.

A family of tree creepers was searching the trunks of the trees. I had never noticed before just how colourful they are, not with the same gaudy beauty as the bullfinches, woodpeckers and pheasants but more subtle, almost like marbling. Their plumage shone with health, ranging through dark mousy-browns to a glowing burnt-amber, contrasting with their light-grey under-parts. My shadow rushed on ahead of me, a good deal taller than me, and disturbed the tortoiseshell butterflies as it crept up on them. To avoid frightening them, I frequently had to come in at a different angle so that the sun threw my shadow behind me. Only then was I able to get close enough for a decent photograph.

Tony built a new fence in order to provide a degree of privacy. Helped by Andrew and David, the job took them half a day. The fence is latticed so that we can still enjoy the wonderful views. The smaller trellis fence, that had been in existence for only a year, was moved to the southern side of the lawn. This left our own accommodation totally enclosed although the wildlife can still get through. I chose two firethorns for the new fence to be draped with: Orange Glow and Mojave (*Pyracantha*). They would encourage the redwings, blackbirds, thrushes and fieldfares. I also chose an ornamental vine, *Vitus coignetiae*, which has large leaves that change colour through green, pink and red. When the leaves have fallen in the winter, the long whippy stems become a purple-red. To complete the effect a bird box was secured on top of an upright post, placed so that I would be able to photograph birds at the nest from our lounge windows without disturbing them. Not being very tall, I hoped to construct a stile so that I could climb the smaller fence without the need to constantly walk across the meadow.

Startled by a vivid flash of electric-blue, I turned to see a kingfisher skimming his way to the backwater. I had seen it fishing in the area many

times, but never this far away from the river or in the sanctuary. At the pool's edge, a mayfly was drying its wings in the sun after climbing the stem of a plant. I bent very close to it in order to take a close-up photograph and hoped that it would not fly up in my face.

The best time to photograph butterflies is early morning when they crawl from their overnight refuge to a sunlit spot where they bask with wings open to catch the suns rays. It is at this time that the intricate wing patterns are fully visible to the photographer.

It was on a visit to the Royal Horticultural Society Gardens that I first saw a magnificent specimen of spurge (*Euphorbia griffithii*) foiled against a group of silver-leaved Chrysanthemums. I have since found out that the *Euphorbia* genus is vast — only a few species are native to Britain and some of those are very invasive. In my few acres I have two unusual varieties planted by myself, *Euphorbia purpurea*, with pinky-purplish leaves and stems and *Variegata*, whose leaves are margined in cream, and whose bracts are also variegated.

While on a visit to the local Garden Centre I bought a *Euphorbia wulfenii*. This variety trails along the ground producing glaucous grey leaves, with heads of greenish-yellow flowers. I was actually looking for the variety *Euphorbia griffithii*, from western Asia, which smothers itself in June with orange heads. However, I bought instead a beautiful variegated plant that rustles in the breeze like dry paper and is labelled Sacred Chinese Bamboo (*Nitida*). For the rockery a dwarf willow caught my eye, the label stated that it was *Salix repens*. It had lovely grey-green leaves and tiny catkins, a perfect miniature of its taller cousins. Would this willow attract insects in the same manner?

As I returned from the garden centre, I was sad to see Crank-Handle dead at the roadside, squashed by a passing car. The toll on the main road was heavy over those particular weeks — three foxes, a male muntjac deer, two grey squirrels and a woodpigeon. Along the lane a young pheasant lay dead at the kerbside and there was a dead weasel only yards from it.

During the summer there had been a glut of bumblebees nesting under the grass in the alpine meadow. They used the vacated mouse holes as entrances to their homes and we had to be careful to avoid the area when mowing the grass.

One evening, the unmistakable shape of a hawk flew from a tree near Badger Lane and the setting sun threw his shadow over the glen. The hawk settled on one of the large branches of the oak, a dark shape against a pinkish sky. I watched as the grey-barred chest changed colour to match the rosy-pink

of the sunset. After much shifting about, he finally settled and I left to creep into my hide for the rest of the evening. Night deepened and sounds were everywhere, so much louder in the darkness. I was surprised by the sound of a large deer crashing along the bank above the sett. The badger, taken by surprise, bolted in fright into a natural chamber beneath a beech tree. Large fronds of bracken obscured the opening made by the tangled roots above the ground. They made a useful door curtain. The sound of rustling and crackling of twigs further off indicated that there were more than two badgers among the vegetation.

A pair of pricked silver-grey ears caught the moonlight. Rowan, ears laid back, emitted angry fox noises. Without any warning, the two tawny-red foxes stood tall in the moonlight with black velvet paws on each other's shoulders, their mouths agape. Soon both retreated to the shrubbery. I could hear a fierce argument between the two of them. The night was full of the noise of mock battles, of yitterings and high-pitched yelps when the cubs' teeth sank into bundles of energy. Foxes are as individual as people and when a strange fox enters the domain of the cubs it is very easy to tell. This information can all be gained by first-hand observation: a stimulating job.

A pitter-patter indicated rain. The noise continued for some time yet the foliage around me remained dry. I discovered the source of the commotion — it came from the rhododendrons. I investigated and found hundreds of attractive red and green North American leafhoppers. They seemed to be on every leaf in various stages of development. I found empty nymph cases where the larvae had shed their skins. They ranged from tiny to half an inch; the insects must be constantly shedding throughout their growing life. On those same rhododendrons John Campbell discovered the rhododendron lacewing, believed to be extinct in Britain. It is now catalogued and in the museum of which he is the curator.

The following evening I was observing from my usual place behind the patio door. By eight o'clock Tansy and Goliath emerged from the undergrowth. Tansy grabbed a piece of meat and dashed off, hotly pursued by Goliath and another cub that had been hidden from view. Tansy stood her ground near the shrubbery, just out of range of my camera, triumphantly gulping the meat.

A fox with a peculiar tail walked slowly across the lawn in full view of us. It was difficult to see where the tail began and ended. It cannot be a coincidence that all the foxes in this area are like this; there must be a common cause. The coat of the fox was a rich glowing red and the bib was soft and fine. I crept around the bush to the right whilst Michelle and Andrew headed off in the other direction. I startled Flag lying up in the rhododendrons,

but Michelle and Andrew had better luck and came face to face with the peculiar-tailed fox. On my way back I spotted oak apples on a branch and dissected one to see the larvae of a gall wasp. The oak tree is especially attractive to gall wasps and other insects.

The postman brought me a letter from the Monkshood Experimental Station and a parcel of recording cards. I could hardly wait to get started. I aimed to record all the varieties of fauna in the reserve and send off the information and results as soon as possible.

Tony had finished making the beautiful descriptive boxes for the sanctuary: they really were quite stunning. Tony, David and Andrew placed them in their positions in the reserve. Each box shows a different subject. One contains my photographs of butterflies and is placed in the butterfly border. Another contains moths. A third depicts mammals and the fourth beetles and insects. The remainder show flowers and conservation plants.

The herbaceous borders were in full bloom, delighting the butterflies and bees alike. There were masses of feathery blooms of golden rod attracting the insect population and a considerable wealth of Michaelmas daisies in the sanctuary. The rudbeckias were crowned with heads of gold. Achillea revitalises the season with its flat plate-like heads. On the top of one, I found a strange insect with huge orange eyes. The thorax and bottom were coloured black and at the waistline was a white belt. It was a creature characteristic of the woodland, its favourite plant bramble. A light breeze blew over the sanctuary and denuded the thistles of their fragile spheres. I caught them on camera exploding like fireworks.

Stonecrop Autumn Joy (*Sedum*) draws butterflies to its rusty red flowers. The double heads of the dahlias and sprays of pom-pom chrysanths are a multitude of colours, ranging through white, lemon, yellow, orange, pink, red and mauve to the almost black heads of dahlia Nero. The bear's breeches (*Acanthus spinosus*) had finished flowering and spray chrysanths Golden treasure and Brightness, a rosy-red, took their place. At the end of the border steel blue stems of Globe thistle (*Echinops ritro*) caught the sunlight.

The blackberries cascaded in huge arcs throwing their arms wide to the sun, whilst the wild hop was clambering upwards. On the blackberries two hedge brown butterflies spread their wings, a mosaic of soft orange and warm browns. As they sunbathed, a solitary brown Argus and a ringlet joined them. The hedge brown, also known as the gatekeeper, has two false eyespots. I counted the spots on the underside of the ringlet: there are fourteen in total. The bright blue pincushions of Devils bit (*Scabious*) are now in full bloom. I planted this with *Small scabious* and *Field scabious* specifically for the

butterflies. The caterpillars of the elephant hawkmoth defoliated the fuchsias. They have a voracious appetite and for them this plant is a gourmet delight, which further enforces that cultivated plants among the wild plants add to the wildlife larder. I placed both the green and brown varieties of caterpillar with their food in a box to pupate and I grew quite attached to them. Once pupated, although they look quite dead, they wriggle madly if you touch them.

However small, anyone's garden can be a sanctuary for wildlife. I look back over the years when gardening was my priority and wonder why my interest in wildlife took so long to develop. I realise that I scarcely noticed the added attraction of bird-song; it was just there. How the change came about I do not know, but I am glad that it did for my gardening is far more interesting now.

Chapter 15
September Woodland Forensics

How proud I felt of our sanctuary. Woodlands with wildflowers are rare these days. Managed by the Forestry Commission, many are clear-felled and replaced with two-thirds pine, larch and other conifers. Sadly, few flowers survive in these newly contrived landscapes. In the natural woodlands surrounding the sanctuary however, the sun filters through the wicked tangle of briars, bryony, ground ivy and periwinkle. The birds are happy in this paradise, having shelter, food and safety.

I made my way slowly through the sanctuary, hoping to see Gos. The mist had almost lifted, and the first of the end-of-season spectaculars was in full swing. A late red admiral fluttered over the dwarf Michaelmas daisies and nuthatches were sampling the berries on the honeysuckles, declaring the restaurant open. I gathered berries, fruits and seeds from the prolific harvest of the hedgerow before the flail-cutter came to sweep it all away again, a spray or two of wild rose, a fluffy wild clematis head and a stem or two of honesty. All make a subtle display, a pick-me-up during the last days of the season. I found three blooms of an escaped Japanese anemone to add to the collection.

The arrangement was placed in a glass vase in the window, to be seen when the low slanting light of the dying sun gave them an added beauty. During the winter months I don't cut down the heads of certain plants or tidy up the sanctuary — the multitude of shapes, leaves and stems encrusted with frost can look superb. Earwigs and other insects hibernate in the hollow

stems of the bamboo. I cut mine to about six inches above soil level, and slide the remaining pieces into a baked bean can. The can is then placed on its side in a suitable place or fastened to a tree for lacewings and solitary bees to use as winter homes.

As evening approached it was time to lay down my gardening tools and pick up my torch. I was amazed at the number of insects that were flying. Some spectacular elephant hawk moths were already attracted to the beam of light.

The bats were hawking for insects over the pool. Our commonest bat is the pipistrelle, which is also the smallest. It was not until we managed to catch one that we realised that it is consists almost entirely of wings. When the umbrella wings are folded, the bat can fit into a matchbox. The owls take over the daytime haunts of the hawks and other birds of prey. Talons at the ready, they swoop on their victims who are taken by surprise, for the owls' feathers are adapted to deaden the noise of the wings cutting through the air.

The nettles had been harvested twice that year, encouraging new growth for the caterpillars and insects. The harvested nettles were not wasted; they were thrown into the water butt where they made excellent plant food. The stinging nettle is the food plant of some of our most colourful butterflies, and also plays host to many of our moths. The nettle bed is very important in a wild garden. The red admiral butterfly lays its eggs only on this particular plant. Ruby tiger moths and ladybirds colonise the area. Given the right conditions, the butterfly population is self-sustaining, for covering the trunks of the oak are tangled ivy plants where the brimstone butterfly chooses to sleep the winter

through. The comma butterfly uses the hedgerow. When its wings are folded, they are hardly distinguishable from a shrivelled leaf, providing excellent camouflage. But we have other butterflies also: purple emperor, brimstone, cabbage white, green-veined white, meadow brown, orange tip, purple hairstreak, small copper, wall brown, white admiral and wood white. All have made their home, breeding and hibernating with us. I completed a survey on the visitors to our buddleias (not including the human variety, of course), cataloguing some.

On a stroll around the far side of the boundary, Tony and I found a large quantity of owl pellets beneath a roosting perch. The owl regurgitates these after a meal. The pellets consist of beetle wing cases, fur, feather and bones. Like a forensic detective, I pulled them apart and was astounded at the number of small bones in each. Anxious to discover more about them, I placed the skeletons on a piece of card to photograph them. I then mounted the skulls and bones and labelled each for the interest of our guests and of the schoolchildren who visit us. Each small skull could be identified by its shape and size and by the teeth. The last pellet caused great excitement as I found what at first I believed to be a bullet. Closer examination revealed that it was a ring from a tiny bird's leg. I rang the telephone number on the ring and gave the details to the RSPB.

At Eeyore's Place where the slope begins, some of the largest *Boletus edulis* fungi that I had ever seen were sprouting from the soil, looking like fat brown buns. Many of the species are edible, but it is very important to identify them carefully before eating them. On the trunks of the silver birch were some strange dark-coloured fungi, called King Alfred's cakes. They were so hard that I had difficulty removing one to study it properly.

I had discovered that the foxes visiting the sanctuary consisted of three groups, all of which I had studied on numerous occasions. All the cubs at Primrose Dell were perfectly normal, conforming to the typical markings of black tear-drops and white tail-tags. They were mirror images of each other, showing no signs of the problems that One-Side-Flash's and Jess's foxes had. Every day I grew more concerned about the defects in the cubs. I was sure that several had survived only because of the care I had given them. The RSPCA were very interested and had let me borrow two sprung traps in which to capture them. Those that were caught were taken to Aylesbury Wildlife Hospital (St Tiggywinkles) where Les and Sue Stocker gave them a thorough examination.

One morning, while serving breakfast, Michelle drew my attention to three fallow deer standing motionless on our lawn. I was debating whether or not to retrieve my camera from the bedroom when all chances to snap them were lost because two of our guests rushed from the hotel making clicking sounds, waving their arms in excitement. We saw three white V's as the deer accelerated into the woods. I find it awfully difficult to get people to understand that the best way to see wildlife is to be quiet and still.

I saw Rudi, the two-year-old stag, browsing quietly under the trees another morning. His spikes had gone, dropped somewhere in the woods. He was in magnificent condition, his coat sleek and shiny. He wandered alone: there was no sign of a doe. Next year would be his third summer and I anticipated his second set of antlers.

I visited Eeyore's Place where the bog had almost dried up and the stream was running slowly in rivulets. The mosquitoes were laying their eggs in the stagnant pools. They buzzed annoyingly around my head with that peculiar singing noise they make. No sooner had I flicked my hair to remove them from my head when others alighted on different parts of my body.

As I walked through the autumn sanctuary I became aware that the air was full of flying insects, covering me in itchy bites. Turning away, I clambered up the banks of the stream but the clay had cracked open and gave way beneath me. I slid rapidly, soaking both feet. The bed of the stream turned cloudy as I stirred up the mud. The water cleared, the pebbles could be seen again and a flash of yellow-gold attracted my attention. On peering closer I realised that it was a grass snake moving upstream, searching for frogs. I spotted the yellow flanges on the head. Turning over a moss-covered rock in the shallows, I noticed the underside was covered in a squirming mass of baby newts, about half an inch long, with tiny reddish-feathered gills.

I was unable to sleep one night and eventually got up at five am for a cup of coffee. A young fox was drinking from the pond. He didn't run from me, but sat down for a grooming session. If he had been born in either March or April he would have been five or six months old, and was in splendid condition. Unlike a puppy, at that age he was quite an adult.

September's new flowers came in from the selection of bulbs that had been planted in the spring. The flower buds of the colchicums sprouted from the ground, the leaves would emerge in the spring. They come in varying shades of pink, purple and white. Meadow saffron grew in the damp area of the meadow and along the woodland borders. The leaves are broad and glossy, but don't appear until March.

The season's hatches of tawny owls were fledged and inhabiting the pines. I hooted and waited in anticipation for a reply. I repeated my call, and with a distinctive wobble in the note the fledgling owl replied. I was evidently on the wrong wavelength. There was no more conversation with them that night as I left to return to the hotel.

I was at the typewriter when I noticed an increase in the number of butterflies. Peacocks with their dark wings closed were lining the inside of a wheelbarrow. I slipped out to take a closer look and found that they seemed to be feeding on the particles of cement adhering to the inside. Throughout the summer, I had gone in pursuit of the elusive butterfly and had ticked off all that I had seen, entering the results in my field book. I was more than pleased with the results.

The days of sunlight became fewer. As I cut across the sanctuary I saw that the wild creatures were lying in food supplies for the winter - a compulsive act of survival. I was at a loss about what to do with the grape harvest. The unthinned grapes hung in copious bunches from the over-laden vines. The blackbirds and thrushes solved the problem however; they were delighted with the crop.

The woodcutters were tidying up the woods and hedges were being trimmed, or laid. The main stems are partially cut and bent over so that the natural upright growth is redirected horizontally. Each branch is interwoven with the next, forming a complete barrier of branches without the gaps that vertically grown bushes produce between each plant and its neighbours. We have a living fence, which allows air currents to pass through but with appreciably less destructive force.

A mixture of tall trees and pollard hedges tops the banks of the lane. The hedges that had been cut the previous spring had new growth rising from the old trunks of recumbent ash. The thin pearly-grey branches moved softly in the wind, serenading the badgers and other creatures of the night. Tricks of light and shade brought about endless changes in the scenery, and dappled the lane with filtered sunlight.

A severe storm hit one night: it seemed as if all the hotel windows on the east side would be blown in. The wooden frames creaked and strained as the storm shrieked and howled. The twin firs, which stand on each side of the stone steps leading to the meadow, swayed and lashed wildly, bent nearly double by the strain. If any trees had succumbed to the wind, we didn't hear them crash. All was drowned in the savage roar of thunder. Tony called Bracken in to the safety of the hotel, fearful that the wind would bring down some of the shallow rooted birches and crush her.

When the storm had passed, we went to assess the damage. My one and only beech tree had succumbed to the high winds, and lay devoid of stature on the ground. The firs were safe, but a silver birch had been torn up by the roots, and in falling had carried with it the limb of an oak. They lay prostrate on the ground near Eeyore's Place. I wondered if the state of the ground there had played any part in the destruction. Two young ash trees also went down in the night. No one heard the crashing sound, so it was impossible to tell at what time they were blown down. The fallen trees would offer its inhabitants a microclimate different from the rest of the sanctuary. A rotting tree is a wildlife bonus, the habitat of many beetles. They lay their eggs in the crevices of the bark, and the grubs eat their way through the soft timber. There are many invertebrates including worms, woodlice and many beetles that gain energy from eating decaying plants. This balance of flora and fauna provides a closely-knit ecosystem with fungi playing an important part as decomposers.

One night, I was wandering along the badger paths. The badger walks with slow deliberation — although it can move very rapidly when it has to — and its low-slung body wears down the grass, creating paths about eighteen inches wide with a smooth appearance similar to the inside of a thrush's nest. The paths are communal; all small creatures, deer, foxes, badgers and myself use them. Badgers use the same well-trodden paths nightly and this is characteristic of them. The first badger hole I came across had several cobwebs strung across its entrance, an obvious indication that no badger had been here for some time.

I spotted something lying on the grass: it was the skeleton of an adult male deer. The antlers were large and impressive, but I was more concerned as to why it had died. The poor creature had clearly been shot through the head. The bullet hole was central and either it had been shot by an excellent marksman or it had been culled at close range. Whether a poachers work or not I would never know.

A new badger sett had been dug out, a pile of discarded bedding alerting me to the badgers' presence. The sett was very close to the sanctuary and was definitely occupied. There are signs of activity, where the occupants had been foraging. On wet nights, indentations of their footprints could be clearly seen.

I bumped into PC Gilligan at Brockmere, checking on the strange activities of the previous week when a crossbow had been found in the wood. He showed me a handful of snares that he had removed from a wood nearby. I was thankful that we had not come across any of those self-locking snares. They are not illegal, but I intend to remove any that I find in my sanctuary.

Chapter 16
Fungi Foraging in October

The month can be mild or cold, clear or foggy, but there are still flowers to be found blooming in the sanctuary. The first sweetly scented pink and white buds of the *Viburnum bodnantense* were beginning to open, and as they matured, velvety white trumpets were revealed. It took a severe frost to damage the blooms, when they shrivelled and turned brown.

Another decorative tree is the young *Arbutus unedo*. It had grown considerably and its glossy evergreen leaves were a perfect foil to the marvellous white pitcher-like flowers. The fruits from the previous year's flowering had remained on the tree, and were gradually developing into strawberry-like balls which turn from yellow to orange and finally ripen to a glorious deep red. The fruits are edible, but I haven't yet tried making jam from them.

In the sanctuary I found one shrub of *Ceratostigma willmottianum* — the only one to have survived from six. They were obviously positioned wrongly and when the autumn leaves of the surrounding shrubs fell away, they were exposed to sharp winds killing off the others in this uncompromising site. The remaining plant had strange prickly hairs on its red stems, and the flowers were intensely blue. Nearby, the beautiful *Mahonia lomariifolia* was in full bloom. It had the largest flowers of our three species. Upright candles of solid yellow appeared from a central spray of handsome but very prickly leaves. The two plants made a striking combination. Beneath the mahonia, a broken bird box had the remains of a robin's nest. I thought I should renovate

116

it but then decided to leave it for the following year's generation of robins. The robins have always been here, alongside the wrens that spend a lot of their time exploring the ivy-covered banks and trees in the sanctuary.

Alongside the mahonia is the winter jasmine (*Jasmine nudiflorum*). I had pruned it well the previous year and it was massed with new shoots starting to bloom. The hebe's foliage had turned a purple-bronze, and the plant was still throwing up the occasional flower. During the previous fortnight, the winter flowers had progressed wonderfully and I noticed with pride that all the buds were ready to open. Holly, with sharp leaves like green glass, gives the garden body. The vivid red berries of the cotoneaster and barberries bring colour to the winter tapestry. My wild service tree (*Sorbus terminalis*) (planted especially for the wildlife) had put on tremendous growth and was seven feet high.

We were enjoying typical English weather: a dripping day, no sun, everything uniform grey. Fog drifted around the sanctuary like plumes of smoke and the tops of the trees were shrouded in a misty veil. Sometimes I caught a glimpse of the view, but just as quickly it disappeared. Summer had conceded to autumn and a continual shower of leaves fell from the trees.

The squirrels were very active taking advantage of the nuts, acorns, and beech mast. The half-eaten nuts, lying on the ground, gave clues to who or what had nibbled them. Each creature tackles the nuts in different ways. Squirrels chisel near the pointed end, to crack the shell length-wise. Mice and voles gnaw holes in the side of the nut. The dormouse makes a much larger hole: reliable evidence of the elusive creature's presence.

By two o'clock in the afternoon the fog had lifted, and everything had solid outlines once again. The conifers on the lawn became green and the woodlands lost their eerie look, inviting us into their mysterious depths. In the sanctuary all was dim. The bracken had died down however, making it easier to spot the roe and muntjac deer. The biggest advantage of that was the clear view I had of the birds: they could be seen high in the treetops. Flocks of long-tailed tits and small groups of gold crests were more noticeable as the canopy of leaves was thinning. The spiders had embroidered the hedges with filigreed webs. To accompany them, fairy bonnets sprung up from the leaf litter, tiny grey, white and pink fungi on long slender stalks.

On the rockery some plants were still in flower, such as *Viola bertolonii*. I lifted a stone: underneath was a population of woodlice who rushed for shelter or curled up in a ball. Nearby were centipedes with masses of tiny legs.

October is the month that my fingers itch to be busy with a pencil and paintbrush, for nature's loveliest colours envelope our sanctuary. The monotonous greens have given way to the deepest of purples, reds and golds. The sanctuary is so colourful in her coat of many colours that I forget that the summer season has slipped past. The tree creeper can be seen quite easily, searching for insects and spiders in the crevices of the oak's rough bark. The birds are now gathered in flocks. Masses of blue tit mingle with great tits and coal tits, but the lovely long-tailed tits remain separate with others of its own species.

Some of the deciduous trees were bare, so we were able to enjoy an uninterrupted view of the sanctuary. Brown and yellowing dry curled beech leaves crackled under my feet. The fruits in the orchard that had not been plucked from the trees by the birds and squirrels remained hanging, ripe and heavy on the branches above my head. A marvellous flush of bracket fungi covered one of the old stumps. Banded in autumn tones of orange, cream and brown, they looked like rashers of streaky bacon. Another small brown fungus in a woody part of the sanctuary pierced through the earth in clusters. I noticed that a few of them had shallow depressions (probably made by a slug) on the surface. Gigantic pearl-like mushrooms pushed their moist heads up through the dew in the skirts of the hedgerow.

I was carrying a small wicker basket, for it was the season of fungi and I hoped with the help of a field guide to identify some of the many species growing here. I stumbled across some shaggy ink caps near Eeyore's Place, where I found that the grass was dotted with their pale luminous blobs. Some of the larger caps were already dripping with black inky fluid containing the spores, which propagate the species. Flies are greatly attracted to these fungi. A very large orange-coloured slug was curled around the stem and I could see where it had eaten, several shallow depressions were left on the cap.

The ground cover on the sanctuary floor had become a lot sparser, and I was able to walk with ease. The deep mystery of the summer was lost. Tiny holes where mice and voles lived were revealed. Near the edge of the wood I discovered a dazzling orange jelly-antler fungus. Its colour was so vivid that I recorded this species on my camera. It was the first time that I had come across that variety. I searched for more, but found only a group of blue-gilled silk parasols flourishing in the leaf litter. Some had been severed at the base and carried off by rodents. I photographed an impressive group of beautiful yellow fungi growing from under the dead tree trunks that support the bank of the ditch at the front of the hotel. It grows in yellow tiers - like a huge chandelier - and brightens up our entrance. Low on the ground beneath the birches, I come across a rare earthstar, which in the past I have mistaken for a puffball. The puffballs were almost hidden beneath the rhododendrons. I squeezed the earthstar and it fired millions of spores into the air. I took it with me on my walk, firing it like a pistol periodically, distributing more of the fungi about the sanctuary.

In that lichen-covered world of acid-greens, grey, mauve, pink and white, I spotted a peculiar variety of fungus. The sample that I picked up was attached to a piece of bark. When I tossed it down again Bracken snatched it up but she very soon discarded it. Maybe it tasted as sharp as the acid-green colouring it sported. I did not pick any of those and continued walking from the sanctuary into the woods. A couple walking along the road had discovered some parasol fungi in the ditch. I left them picking large quantities. I love mushrooms, but I hesitate to serve any to our guests in case the morning's breakfast lands them in hospital.

I gathered boteli of all sorts. The stags-horn fungus stands upright, hard to the touch and pure white, like sea coral, small-branching stems of great delicacy. I found the smallest parasols of dingy mauve supported on the longest stems I had ever seen. To take a photograph, I had to lie on the ground and shoot from a low angle in order to emphasise their height. Everywhere, there were gilled mushrooms of sepia, grey and green with olive-yellow under parts: some minute, others large and impressive. The

most eye-catching were those of *Clitocybie*. Slimy to touch, they glow wetly in the shade with a strange white luminescence.

There was a lovely smell of bonfire smoke as I walked up the lane. Leaves littered the ground at the kerbside and there were still a few glowing conkers among them. An ash growing in sandy soil beside the path had several small mossy cavities. Inside the hollows I found the remains of nuts placed there by some creature. In the distance, smoke rose from Hill farm fields. They had all been harvested and only the stubble was left, burning slowly. The field mice must have felt bereft at the sudden disappearance of the wheat.

A mysterious popping came from a patch of wild capsicums. The pods cracked and a seed flew through the air like a bullet. All around the propagation continued. The seeds of the rosebay willow herb are different: they float away on fairy parachutes. The dandelions have similar seeds that are distributed by the wind. The ash trees have pale green keys. Each seed is enclosed between two paper-thin discs with a twist in them like the blades of a ship's propeller. The plant silver pennies (*Lunaria*) has its seeds enclosed, between two translucent silver discs. The maple also sheds keys that spin round and round as they fall to earth.

Lying squashed on the road were horse chestnuts encased in prickly husks of green. Inside each spiky ball was a lovely smooth lining, the palest of grey glistening like satin. When the horse chestnuts are ripe they fall from the trees and the prickly burrs split to reveal plump, highly polished chestnuts hidden within. We spent time collecting the emerald-green shells and releasing the round mahogany nuts to the delight of our grandchildren. They are much different from the burrs of the lady's bedstraw that cling so tightly to our coats and socks and are so difficult to pull off. Poor Bracken, pushing through the undergrowth, gets covered in them, for the tiny hooks catch and cling to her hair.

Autumn is my favourite season, due to its flamboyancy that can be apparent everywhere. We tend to think of fragrance as a spring and summer feature, yet autumn can boast perfume to rival that of the roses and lilies of those lazy August days. Autumn brings mornings heavy with dew, which drips constantly from the sanctuary trees reminding me of an exotic rain forest. The garden is always changing and improving, providing secure sanctuary food and shelter for the wildlife.

A highlight one week was a walk with a group of naturalists through the wood in search of fungi. With plastic bags and containers, we followed the paths around Hazel Copse, Brockmere, the Glen and the Spinney in pursuit of different specimens. What the textbook did not tell us is that a tiny button

mushroom can look entirely different from one day to the next. That day it was large and white with under-curled edges and fine grey gills. By placing the fungi on a sheet of paper you eventually see the released spores, some of which can be quite colourful.

Several species of bracket fungus grow throughout the year, and last seemingly forever, jutting from the trees in a strange fashion. In frosty weather they freeze hard as a stone. In the sanctuary, I caught sight of a nuthatch using the fungus as a perch as he hammered away on a nut wedged between two branches. Nearby was a strange type of fungus. On investigating, I discovered that what I thought was fungi was in fact a row of silver pennies from a *Lunaria* wedged in the crevices of the bark. As I stared, a nuthatch appeared carrying a trophy in its beak. Twisting his head he contrived to place the penny in his bank next to the others.

I only admire the fungi and never eat them, preferring to gaze at the brilliant colours of the beefsteak fungi, the 'fairy toadstool', and the fly agarics with its parasols of red embossed with white spots. This fungus is very poisonous and known to some as the magic mushroom. The fungi known as versicolour with its many zoned concentric streaks of reds and browns looks strangely like an underwater coral reef. I found some on a moss-covered tree stump, the background of damp glistening moss hiding the dead wood. Beauty such as that enhances a mid-winter walk. Our greatest find was the Magpie ink cap in the depths of Hazel Copse; its giraffe-like geometrical markings in cream and brown look beautiful at all stages of growth.

We had a group of wildlife photographers booked into the hotel. At four–thirty the first of the group arrived, carrying camera equipment of all kinds. The organiser, Mr Martin Brown, said that I could join their lectures if I wished but of course it was impossible as I had to organise their coffee and meal breaks. At around five–thirty I took a phone call from the lecturer, saying he believed that the course had been cancelled. This presented a problem, for twelve of our bedroom spaces had been allocated to the group. The photographers continued to arrive at the hotel, expecting to see the group leader there to greet them.

Martin Brown telephoned the lecturer and confirmed that he definitely would not be arriving. A replacement lecturer had been found for Saturday — Mr Neil King — but Mr Brown had no one for that night. After giving the group a good meal, I offered to open up the conference room and show them some of my own slides and photographs of the wildlife around us. Having a slide projector proved to be a boon and the evening was saved, each photographer showing his own slides to the rest of the party. We ended up with a two-hour session and a talk on wildlife by myself. The foxes received

their dinner very late indeed and ate it without my company on that very unusual occasion. At twelve o'clock I retired to bed exhausted and with no ambition to become a lecturer.

The following day brought clear sunny weather and three large deer on the lawn at breakfast time, exciting all the photographers and giving them a taste of what was to come. Unlike the other guests, the members of the photography group remained silent, content to observe. There was no light-coloured clothing, no perfume or rustling bags and no creaking plastic coats to expose our presence to the wildlife.

At ten-thirty I met Neil King in reception and explained the previous night's situation. He was a very pleasant man who invited me to wander in and out of his lecture at will. Things were definitely going well during our very first wildlife weekend. During lunch I received a phone call from Tim Hallchurch, a bird ringer and naturalist. He asked if he could put up his mist nets on Sunday morning in order to check the bird population that he ringed at the end of May that year. That would be an unexpected bonus for the group.

The weather had changed after the previous day's beautiful day; a heavy grey mist hung over the garden. We heard Tim arrive at six o'clock with his accomplice in order to erect the nets. Misty weather and mist nets seemed to go together. By the time that we had surfaced, Tim had set up five nets in strategic positions around the garden.

At nine–fifteen I met Gordon Langsbury, whose main interest is bird photography. He and Tim got on very well together but the weather let us down that day. It was so awful that Tim caught only three birds — they just weren't flying. He gave up at ten o'clock as the mist had thickened to a fog. He said he would return in about three weeks. Gordon Langsbury later published a book on photography techniques, which I bought a signed copy of.

The sun appeared soon after lunch and the group were taken into the woods for some practical photography. They found lots of fungi, many frogs and two dragonflies in the wet vegetation. The latter were impossible to photograph because of their reluctance to leave the tree canopy. The guests shot many reels of film. After dinner that night, all members of the group gathered to watch me feed the foxes. I asked them to keep the room in darkness and they were rewarded by the sight of four cubs arriving to feed. Later, they were further entranced by the presence of the badgers.

I awoke one morning to the sound of our winter visitors, the fieldfares and redwings. They were having a marvellous time feasting on the firethorn and holly berries. The view from my window was spectacular, autumn colours everywhere. The bracken fronds were dyed russet-brown or golden-yellow. A

few golden leaves clung tenaciously to the otherwise bare branches of the birches, and two glorious spindle trees (*Euonymus europus*) were dripping with tiny coral berries. A berry had split, revealing its vivid orange seeds.

Tony and I left the hotel at two-thirty and walked through the sanctuary into the woods. They were filled with the rustling sound of falling leaves, and we could hear a nuthatch hammering on a nut. Looking up I could see him: a young bird, probably that year's fledgling, a duller version of the more colourful adults. Tony picked up some acorns and a few branches of the coral-red spindle berries. I took them back with me to paint as they would make an interesting still life.

Later that evening the foxes were very vocal, calling from Hazel Copse. I could hear a good deal of barking from the vixen and short yaps from the dog fox. In the distance a domestic dog joined in the chorus.

I decided to go on another fungus forage. I discovered a magnificent brown toadstool in the lawn and a great cluster of yellow fungi around the base of a dead lilac. I found them to be especially photogenic, and I took pictures from beneath, lying flat on my stomach. They had sprouted from the ground almost overnight, giving me a good excuse not to mow the grass. The spectacular orange jelly antler fungus that we had found earlier in the month disappeared after just two days and I could only assume that the deer or the mice had eaten it.

While out on my forage, I noticed a tawny owl acting strangely. It was flying very slowly through the sanctuary in broad daylight. The lovely bird was in obvious trouble. It finally alighted on a silver birch and seemingly nodded off to sleep.

We were having torrential hailstorms. Tracy, a member of staff, arrived an hour late on her coach from Gloucester and a guest took five hours to arrive from London — at least three hours longer than normal. That evening, I didn't put out any food as I felt sure that the foxes wouldn't come in that dreadful weather. I would be able to have an early night for a change, as I was always drawn to watch if food was there and the foxes were waiting.

It had rained all night and, despite the weather, flocks of fat woodpigeons strutted about our lawn like domestic hens. The camera was focused and on its tripod but when I move the curtains for a better view the pigeons flew off with a loud flapping of wings.

It was getting more difficult to see the berries on the spindle as the leaves were turning the same colour. There were three new buds on the autumn crocus (*Colchicum autumnal*) and their mauve colour was brilliant against the dark wet sedge peat in which they were growing. The rest of the

blooms were sodden and bedraggled, lying limp on the ground. For length of flowering time they were hard to beat: for four weeks they had blossomed.

David MacDonald was surprised that the members of the fox group were still together. It was of course possible that they had gone their own way and met up again in the sanctuary. If that was so, I was amazed at the degree of affection among the group. David was very interested in the photographs that I had taken of the deformed foxes and we planned another meeting so that I could show him the evidence. If the cubs were to breed the following year with the same defects present, Oxford Scientific Films hoped to be able to make a programme, with One-Sided-Flash as star performer.

Jess, the sandy vixen, jumped down from the bank ahead of me and ran some considerable distance along the ride. It was the first time that I had seen her since July. That evening Flag approached and made his usual half-circle with the wind full in his face. He came close to where I was seated and stood silently near me. I did not move or attempt to touch him. I noticed how much of an adult he had become; the velvety black ears always pricked, he was lithe and supple but maturity brought with it a suspicion of noises. I was glad the cubs were completely wild; everything was as it should be.

It was becoming increasingly dark, thickening clouds were scudding across the sky and a few raindrops began to fall. The day ended in a terrific storm. Everything was in chaos; the gusts of wind bent the trees helplessly. I glanced out of the window at three am to see branches, twigs, fencing, flowerpots being hurled across the lawn. I watched the force of the wind snapping heavy oak branches as if they were mere twigs. Like the mast of a ship, the tall ash trees whipped too and fro in the fierce wind.

The guests stayed inside the walls of the hotel, while I decided to brave the fury of the night and retrieve my camera from the hide. Between the gusts the silence was awesome. The wood was mine — not a single creature was present. Every time I stepped into a clearing the wind tried to rip the coat from my back. Overhead the clouds were boiling dark grey and purple, bubbling over each other in haste, blown angrily across the sky.

I had never loved the woodland more: wild and sinister, howling, rustling and roaring accompanied by a sizzling downpour. Sheets of water filled the hollows in the ground. The badger paths became small but angry streams. The sanctuary was lit more brightly than floodlight as lightning penetrated the darkness. A vicious clap of thunder rolled through the air, making me jump. The great oaks were standing solid against the wind but every now and then a strong gust caused them to flail their arms wildly. As the storm showed no sign of abating and I grabbed my camera and ran home among fallen twigs and branches.

The following day, extracts from the daily newspaper included: "The fire and police 999 calls reach a rate of one every two seconds"; "The M25 between junctions one and seven is closed"; "The M25 between junctions twenty-seven and twenty-eight is closed" and "In Herefordshire, the road to St Albans is closed".

I went out expecting to find the trees naked, shorn of their foliage. It was strange that they were still clinging to their leaves, proving that they will only fall when nature intends. The hurricane had felled many trees. The birds were not flying, but the seed left for them on the bird table was. Where the ground hollowed there were large puddles rippling in the wind, and reflections of marbled clouds racing across the sky. I heard a strange noise at the sanctuary edge, and went to investigate, narrowly missing being crushed by a falling tree. This upset and frightened me so much that I returned to the hotel and stayed there for the rest of the day.

The farmer down the hill had acquired some large lakes: three of his lower fields were flooded to a depth of ten inches and gulls swam over the surface. The marshy ground at Eeyore's Place was even more so after the rain, and I slipped and squelched my way to the glen in order to track down the cubs. They were almost adult and by the beginning of the following year they would all have found mates.

A fierce wind — around forty miles an hour — was still roaring angrily through the sanctuary. The trees kept up a savage whine until I retired to bed and sleep obliterated the sound.

The next day dawned clear and sunny. The new chalet was standing on its concrete base, ready for the following year's filming sessions. It had been placed further down the garden than my hide, where I would have an uninterrupted view of the cubs coming to the shrubbery. It was where they would probably conceal themselves while waiting for food. The windows look out onto a grassy area, not quite a lawn, to the orchard beyond. It was from those bracken-covered slopes that the foxes had entered the sanctuary, after first crossing the stream. The new outlook would provide me with some unusual photography. Maybe the cubs would use the fallen tree across the stream as a bridge. I could not think of a more enthralling photograph that I could take the following April than one showing several tiny cubs full of mischief, scrambling across the area where lemon-yellow primroses would grow in every crevice and along the banks of the stream.

The shrubs and plants that I had ordered the previous spring had arrived and were waiting in their corrugated paper jackets for me to unwrap them. The ground was dug and ready and with Andrew's help we would have

the shrubs in their final positions by the middle of the day. Purple sage (*Salvia officinalis*) that I would keep clipped was to grace the centre of the border, with bugle (*Ajuga reptans Atropurpurea*) as an edging, providing a fine display of intense violet-blue spikes in early summer. I also planted the dwarf (*Hebe pinguifolia pagei*), an evergreen, which is covered in short spires of white flowers around May. Finally, the walls were to be clothed with *Ceanothus thyrsiflorus* and John Williams (*Clematis*).

The foxes were extremely early, arriving at seven-thirty one evening. It was a cold starry night. I looked up at the solar system; the Great Bear could be seen easily. I sat with the French doors slightly open. A coolness in the air could be felt and I draped a cardigan over my shoulders to keep warm.

Our first winter visitor, the redwing from Scandinavia bearing startling red flanks, was perched close to a rose. In the background, the deeper red of the hawthorn berries glowed vibrantly. Many of our shrubs were loaded with fruits and berries. I wondered if that was a sign of a long harsh winter season. The leaves that were swept from the oak trees by the previous day's blustery wind and rain lay beneath the trunks in a wet solid mass. A blackbird tossed them aside, depriving the slugs and worms of their shelter, and had a quick lunch of some of the unfortunate creatures. It was a pity that the badgers didn't do the same as they had been worming in the lawns, leaving them pitted with a dozen small holes.

Through my binoculars I could make out the shape of a kestrel hovering over the glen. Suddenly he plunged to the ground with feet thrust forward, and dropped on an unwary creature with an excited 'Kek-Kek'.

It was late in the evening and, straining my eyes, I could see no sign of the foxes popping up from the undergrowth so left the night scope in its leather case. The cubs, well grown, still showed signs of recognition when they met. I had stopped putting out food for them; they were quite capable of fending for themselves.

Chapter 17
Dwindling November Reserves

My mainly acid soil gives me great scope for the most sensational winter-foliage woodland plants. *Enkianthus campanulatus* turns orange-red and its partner *Pieris formosa* sports leaves of brilliant scarlet in the spring, fading through pink to yellow before turning green. Heathers bloom in shades of red, pink and white from December through to April. Some of the heather's foliage is brighter than the flowers: brilliant gold or, with heather Robert Chapman, the foliage is a magnificent bronze-yellow, later light orange, but in the depths of winter the plant is a glorious bronze-red. I planted meadow saffron (*Colchicum autumnalis*) and *Colchicum speciosum*, both of which bear amethyst pink flowers (a difficult colour to place) alongside *Cyclamen coum* and Betty (*Phlox*), whose pink eye picked up the startling colour of the colchicums and made the association harmonious.

From August to October the blue-flowering *Plumbago ceratostigma Willmottianum*, a three-feet-high shrub, grows in a sheltered corner protected by a wall. Around the edge of the pond, deep blue spires of *Hyssop officinale* partner the pale pink knotweed (*Polygonum vaccinifolium*), which I grew from seed. The effect is a misty haze of pinky-blue reflected in the water.

There are so many different species of bellflower (*Campanula*). Some are like fairy thimbles, others have a large open bowl-shape and some are star-like. We grow *Campanula carpatica, C. garganica, C. cochlearifolia* and *C. portenschlagiana*. Slow-growing Severn Sea (*Rosemary*) occupies its own tub on the patio. Surprisingly, we have no flowering currant, though I hope

127

to correct this. The blue globe thistle (*Echinops variegata*) is still one of my favourites: the globular heads are a metallic steel blue, rising above marvellously contoured foliage. My other sculptured plant is bear's breeches (*Acanthus*) with prickly purple-tinged foliage and clusters of pink bracts covering the plant: highly arresting.

On the opposite wall, the *Vitis coignetiae* that had been planted the previous June could be seen. This vigorous climbing plant has heart-shaped leaves that turn fiery shades of crimson and pink in the autumn. The borders are massed with fuchsias of every conceivable hue. They are treated like bedding plants: I take them up in early December and over-winter them in the greenhouse. The variety Texas Longhorn is particularly spectacular with layers of white frilly underskirts. The plant is a trailer, but it is worth training up a wall. The perfect white form of another hybrid, Sleigh Bells, is superb in a shady corner as the sunlight tends to turn it pink. A real classic, it always reminds me of the ballet Swan Lake. Contrasting greatly with this is the flamboyant Rigoletto, a gypsy dancer in violet and purple skirts, overlaid with deep red. Growing on the mesh supports is an ornamental quince Knap Hill Scarlet (*Chaenomeles*), also known as japonica, and a wild clematis.

Bracken was confined to the hotel as it was November the fifth: bonfire night. We watched the firework display from the lane. Higher and higher danced the flames. The sparks from the bonfire gave a display of their own with each crackle of wood. When I walked up the lane the following day there was a lovely smell of wood smoke hanging in the air, empty firework cases littering the ground and the earth was scarred with a thick layer of ash, suffocating all living vegetation.

I was pleased to see Bob striding down the lane towards me. What a lot of news I had to tell him, and he was equally pleased to see me. His news was much more dramatic and disturbing than my own. After he'd left the previous Friday, he went to check Cow Lane sett. There he found a dead badger, snared in the entrance. Bob removed the snare and took it home. He also had his camera with him and took photographs of the dead animal to show the RSPCA.

We had a long chat about it and decided to check all the badger setts. Briarbank sett had been dug out and completely destroyed. I wondered if the badgers had escaped. The stricken oak sett was alright, so too were Hazel Copse and Brockmere setts. I told Bob of the old sett I'd found that was dug out afresh by a badger and of my belief that this one might have moved here from Briarbank.

Bob came to see me again the following day as Inspector Gilligan and two RSPCA officers were calling round. We told them of the strange arrows we had been finding recently. We had just come to realise that the battery attached to the upper part was not simply to provide weight; it was connected to a tracking device on the arrow. Apparently this was for tracking the deer once it had been shot. The victim very often took a while to die and wounded deer will continue running in terror and pain. Could that have been the fate of the deer I'd found in October?

We were all very concerned about the sudden spate of illegal activity in the woods. It had never been seen or heard of before in this area. Determined predators would probably encourage Gos to fly off to a new habitat.

It struck me how much wider the lane appeared to be as the bank side vegetation was dying down. At Eeyore's Place, I came across a trail of dead bracken. The badgers had been busy replenishing their bedding. The previous year's leftovers were brought back into the cycle of life. The fruit in the orchard was keeping the fieldfares, redwings and blackbirds very busy, just as I knew it would. It was a scene of great activity and much fluttering of wings. Redpolls in groups were with the siskins, frequenting the birch trees where they fed.

The mole was going berserk; its upheaval of my orchard had resulted in a mass of small mounds beneath the trees. He didn't tunnel close to the hedgerow, but started a little way out and churned up hills over a large area. Moles are particularly active in November and December, and again in February. The vigorous tunnelling was brought on by the colder weather, now that food which had been previously plentiful had become scarce. As the soil becomes colder, invertebrates live lower down and the mole has to excavate deeper to find food. The hedgerow spiders had spun hundreds of elaborate webs; a mad embellishment of silken threads adorned the bushes. I observed both orb and sheet webs. Some of the spiders were still lurking nearby spinning or crouching on the lacy structures.

Later in the afternoon I remembered that I had left my camera inside the pocket of my hide, so I returned to retrieve it. I could hear a rustling sound inside the tent and I knew that I was not alone. Cautiously, I undid the zip as quietly as possible and taking a deep breath, peered inside. The cheeky face of a young grey squirrel stared back at me. He had been having a feast on the food that I had brought down previously to entice the birds and animals to my camera.

I saw the tail-less fox that night. She could no longer be called a cub, for she was eight months old. 'What you never had you never miss', goes the

old proverb. Although she had no tail, she seemed contented enough. I often wondered if the normal cubs noticed the strangeness of their relatives.

We were pretty certain that at least one pair of foxes would breed there and that it would most probably be Flag and the tiny stranger with the crooked tail. However, there were also Rowan, Jasper, and Darky who come regularly into the sanctuary. I could only wait until the following spring for the outcome.

A concerted effort was planned to catch one of the cubs. She was almost blind, nearly deaf, lame on the left hind leg and covered in an encrustation of grey fungus-like growth.

Our lounge looked as if it was equipped for a safari. A wire cage was at the ready and a huge net similar to those used for hunting butterflies, with a ten-foot extension handle, lay on the carpet. The trap was baited and Albert Honey (Wildlife Rescue), Douglas Davidson (RSPCA), Chris Simpkins (RSPCA), Les Stocker (Wildlife Hospital), Tony and I were all waiting. A single fox appeared that night and skirted around the trap. Although the trap was baited with the most enticing of food, the fox was no fool and would not enter. Three nights later a stranger visited us: a fox in perfect condition. There was no sign of the pathetically ill fox. We presumed that she had died, probably just before we received the trap.

The following day we had another important visitor: David Bellamy was officially opening our Nature Reserve. David was staying with us for three nights as the following day he was giving a talk on wildlife at the Oxford Town Hall and also launching his new book, *England's Last Wilderness*. I was thrilled when Tony managed to reserve tickets.

David's talk was very informative and a joy to listen to. The talk, which was illustrated with slides of some of the places he had visited, was well received by a large audience. Before he left he gave me a signed copy of his book.

The opening ceremony went very well and TV South, Oxford Scientific Films, and Radio Oxford were present. The weather was excellent, and we provided a buffet lunch for everyone. The unveiling was a huge success and was of great interest to our American, Canadian and Japanese visitors. Cameras were clicking, video cameras rolling and the radio interviewer had her tape permanently switched on.

I sneaked out before dusk to be with Tony. We see much more like this, away from the chattering voices of others. The air was full of the scent of damp woodland, dying vegetation and of fungi. The jays were noisy, digging up acorns they had buried the previous month. Canadian geese rose from the

river, and I watched their wings flapping in unison. We saw a vast number of starlings, swooping from one tree to another. They would settle, and then simultaneously, as though they had been shaken from the trees, they would rise and constantly sweep around in black circles, until descending as one onto the farmer's fields. They are highly photogenic in their white-spotted purple-black plumage.

The autumn colour of the trees in our sanctuary could be seen from the bottom of the lane and when the low beams of sunlight caught them they were lit in a halo of light. The beeches contributed to the colourful spectacle in shades of brown or orange, but the most beautiful of all were our wild cherries, aflame with crimson. The first tree to turn colour was the Senkaki (*Acer palmatum*), a lovely clear yellow. When I caught sight of it one afternoon, it was shining like gold.

I went with Bracken to rake up the autumn leaves. When I had them in a tidy pile Bracken annoyed me by nosing through the heap. She amused herself by getting as many airborne as possible. I gave up as a sudden gust of wind whipped the leaves up in frenzy, much to Bracken's delight. She spent the rest of the morning chasing and rustling them like tissue paper.

Michelle and Andrew came to find me. A bird was lying on the road, another roadkill statistic. Michelle thought that it was a bird of prey so I went to look in case it had been a member of Gos's family. I brought it back to the woodshed. Its wings were broad and its back beautifully flecked with white, as if the bird had been sitting in a snowstorm. The warm brown bird was dying and I felt sad: its powerful legs were feathered to its toes in a soft grey. It was a young tawny owl.

Soon afterwards we found yet another casualty, a badger this time. The injured badger was a female, unconscious but still warm and breathing. The only apparent injury was a graze below the chin, which could have been caused by the head hitting the road.

November heralds the first stages of winter, with its short, damp days. In the garden there is a smell of damp and decay mixed with the sweet elusive scent of the *Sarcococcas* and the perfume of *Viburnum bodnantense Dawn*. There is loveliness about the wild untidy sanctuary in the winter. By that I do not mean overgrown and weed-infested but the sanctuary clad in thick frost, sparkling and clean. When the shrubs and trees assume new beauty with blossoms of liquid silver, the sanctuary is transformed into a magical place. When this happens, an enveloping hush hangs over the countryside and the smallest whispers are magnified.

The trunks of the trees are spectacular at that time of the year. Snake bark maple shows its silver-green striations, whilst the *Arbutus* has bark of

cinnamon brown. Underneath the leaf litter is a mass of living tissue: tiny parasols held aloft. Nearby the *Mycenae galopus* flourishes in the leaf mould. A wood decomposer covers the sides and top of a stump left to rot in the ground. The white growths of the stag horn play a part in the ecology of the sanctuary.

An owl hoots and another answers. My body goes to sleep before my mind does, always alert listening to the music of the night. I finally fell asleep around three o'clock, still protesting. Sleep is a waste of time.

Chapter 18
Scarlet Berries of December

The exhilarating month of Christmas had arrived — the month of fiery colours, festivities and the busiest time of the year.

All the reds, oranges and browns were on show, burning a trail through the sanctuary. The berries on the yew tree were red as blood, the bryony, nightshade and rosehips were showing red, green and orange and the translucent shining red berries of the arum lilies contrasted dramatically with the fleshy orange berries of the stinking iris. A blackbird picked a cotoneaster berry from the shrub walk and, lifting his head high, gulped it down while staring at me with his bright black, yellow-rimmed eyes.

Each year the dark-leaved hollies are aflame with clusters of colourful berries. I collected a few branches to make winter bouquets before the birds stripped them. Only the lower branches were festooned — the observant redwings and fieldfares had long since plucked the clusters at the top. The garden doesn't belong to me: I only maintain it and provide food and shelter for the residents. Tougher weather would soon be upon us and the last of the roses would wither and shed their remaining leaves. The rosehips would remain on the bushes until devoured by my feathered friends.

Autumn shades could be seen everywhere in the sanctuary. Those dramatic colours are an essential part of winter; the Acers provide some of the best scarlets, but *Rubus phoenicolasius* with its bright hairy stems that look superb in winter is a close contender. Catching the low sunlight, the bristles on the stems are lit from behind and glow an intense red. *Rubus*

cockburnianus, the ghost bramble, was showing its pure white stems, delighting us all. Two other small trees were planted among the oaks, a *Sorbus terminalis* (which unfortunately turned out to be *Sorbus intermedia* and disappointingly not very appealing to the birds) and contorta (*Corylus avellana*) with its curiously twisted growth habit. Its common name of corkscrew hazel comes from its amazing shape, suggesting it has received an electric shock.

The seasons flower is the Christmas rose or hellebore, with dark glossy-green foliage and white blossoms tinged with pink. It is related to the winter aconite, which flowers in February. All through the winter Lamiums (commonly know as dead nettle) spread through the copse. Their leaves are particularly beautiful. Blotched with white markings, they spread their runners over the ground in the same manner as strawberries. In spring, the deep pink honeysuckle-shaped flowers are massed on the plant and attract the early insects.

The Christmas festivities are synonymous with the robin. He enjoys our company, staying close when we are in the garden. One even became tame enough to take a crumb of cheese from my hand.

Wildlife can be seen more easily when the bushes and trees are naked. All around, fallen leaves provide a multi-coloured carpet over the sanctuary floor. At that time of the year, most of the trees have been bare of leaves for a while. The silver birch is the easiest to recognise with its delicate form and lovely trunk. The low sunlight dramatises the oaks blackened twigs. The trees look magnificent, their strong outstretched branches flung across the sky.

Grey and black are the first colours that come to mind when winter arrives, grey fog, long dark evenings, black thunderous clouds and the stark outlines of the trees. Black can bring sharp contrast into the sanctuary and my black grass (*Ophiopogon planiscapus Nigrescens*) is superb against the pale grey rockery stone. There is black in the farmer's field in the form of sturdy Welsh cattle. The leaf mould is blackened by rain and on the bare earth lie blackened horse chestnuts.

As the weather gets colder, the birds become tamer. Guests that are taking a meal in the restaurant make a beeline to sit in the chairs at the windows. They take great delight in watching the antics of the grey squirrels that have lost their fear of humans as they search for food. The sight of nuthatches, siskins and great spotted woodpeckers at the feeder has people standing up from their breakfast for a better view. This was a test of the sanctuary: its ability to maintain form, interest and structure throughout the winter months. I had shed any idea of formal gardening and placed my

thoughts firmly on the sanctuary. A plant has to be more than just flowers: it needs to be spring flowers, summer foliage, autumn fruits, winter scents or sculptured architecture in the harsh months.

The first of the Christmas parties at the hotel was held one Friday. Tony and I cut armfuls of soft green pine branches. I couldn't resist burying my head in the foliage and breathing deeply the tangy scent, which smelt strongly of nutmeg and cinnamon. We walked into the clearing made by the woodcutters who felled the Christmas trees. There were logs neatly stacked in piles, and bundles of firewood lying haphazardly on the ground.

Half a dozen people stood laughing around a fire, which spat and glowed warmly in the centre of the clearing. As the slightly damp resinous fir crackled, it sent sparks flying. Heads lifted to watch as they glowed and flew across the sanctuary. An aromatic smoke filled the atmosphere, but people payed little attention to it as they chose the finest, shapeliest, tree to adorn their house. One of ours, for the courtyard, was a stately ten feet tall; the other for the lounge was a more modest five feet.

Heavily laden, we decided to walk a straight path home, but ended up making a considerable diversion to gather holly and a quantity of fir. Every now and then a laden spruce would release a powdery avalanche from its branches, which blew back in our faces. As we trudged doggedly up the slope, the snow creaked like squeaky floorboards beneath our feet. When we carried the pine branches indoors, they sparkled with wet crystals as the snow melted.

We had polished all the brass and copper lamps until they shone like gold, ready for the party. Every candlestick, encircled with berries and cones, was ready to hold its lit red or green candle. Our Christmas starts early due to the number of office parties held at the hotel. Bracken fronds, a rich dark-brown or amber-gold, were arranged in vases with orange rosehips, honesty (silver pennies) and fir cones.

I gathered ivy from the gnarled trunks of the oaks, fir and heather from the heath, fir cones and angelica heads, the latter two to be sprayed with silver and gold lacquer. Teasels, which have fed insects (notably dragonflies) and finches throughout the season, are also useful for livening up flower arrangements. Ivy and mistletoe hung around the hotel in garlands, and long strands of trailing leaves were threaded through the balustrades of the oak staircase. Clusters of vivid scarlet berries and tiny silver bells hung above the French Riviera and Spanish paintings. The scent of the woodland was strong; the fragrance of moss and chamomile around the indoor water display pervaded the room. Tiny glass fairies were perched precariously around the rim — one careless nudge and they would be taking a bath.

I went with Tony to post the Christmas cards that we had finished writing. The pillar-box was so full that we had to walk to the second one at the bottom of Cow Lane. Even then, we had difficulty posting the cards, for that one was almost full as well. On the face of the letterbox it said 'Post early for Christmas'. We continued our walk to the city. Like a child, the anticipation of Christmas gripped me. I wasted time staring at the displays in the shop windows. The animated display at Selfridges drew a large crowd and I enjoyed the expressions on the children's faces. In the covered market, city shoppers clustered around the butchers' and poulterers' stalls, where dozens of plump turkeys, chicken and ducks hung in rows, featherless and pot-bellied. Braces of pheasants swung gently on metal hooks: even in death the male's feathers are brilliant.

When we returned home we found that Andrew and David had decorated the courtyard at the front of the hotel; there were small coloured lanterns strung around its arches. The light from them shone down on the golden-brown gravel yard below. The courtyard was particularly beautiful: the tiny resinous stones have a permanently wet look, shining like topaz, jets and diamonds. The hanging baskets that were once filled with glorious summer bedding plants were just as colourful filled with holly, ferns, ivy, miniature crackers and tiny gift-wrapped parcels in colourful waterproof cellophane.

In the darkness outside, our impressive tree stood with its fairy lights twinkling. The problem was that guests thought that that was the main entrance. We gazed at the scene with quiet pride, and planned how we would put straw on the ground and have a nativity scene in the courtyard the following year.

Only the howls of the wind and the swish of the rain broke the silence of the sanctuary. It was the windiest day on record and the road was strewn with fallen trees. One was blocking the road, its massive branches jutting out at all angles. I dashed back to the hotel to make an emergency call to the rescue services. The tree had fallen across a bend in the road and a police presence was needed to warn oncoming motorists. Tony, David, Andrew and Jon were already working desperately on the tree with chain saws (although the trees was not one of ours) when the emergency services arrived. The tree lay stripped of all its stature, its boughs amputated and slung in the hedgerow.

Later that evening we took some carrots to the donkey in the lower field. The light was fading fast as we left him and walked back along the lane. Bracken kept pushing her cold nose into Tony's hand. We passed the well-lit windows of the house on the corner. Through one pane of glass we could see Christmas cards on the shelf above the fire. In the garden, the

giant fir was ablaze with coloured lights. There were five of those trees on the hill, illuminated by their owners. A passer-by, her arms full of holly gathered from the wood, asked if we knew where the mistletoe was growing.

Unusually for December, we had snow upon snow. Eventually the snowplough arrived. The packed snow was as hard and slippery as an ice rink. We looked out at the scene, wondering if any impression could be made on its surface. For three days now our guests had been unable to leave and guests due in had not arrived. We were left pondering on the numerous parties booked. One by one the cancellations came in, sometimes too late, as turkeys had been prepared and mince pies cooked. Christmas crackers had been bought in twelve-dozen packets. The radio reporter announced that more snow was on the way. We waited, apprehension growing as we kept our eyes on the sky. The first flake alighted like a feather as the telephone rang, bringing yet another cancellation. The snow was falling in earnest and the snowplough had been left discarded at the side of the road.

 Much as I love the snow the frost thrills me more. I awoke to a bleak December dawn with frost still thick on the grass and found that the stems and leaves on the plants were encrusted with rime. Jack Frost the artist had excelled himself that morning and had tipped each plant carefully with silver. The apples that were left hanging on the trees had a fine tracery of silver

over their red and green Christmas colours. Our mahonias were a fine example of the beauty I behold as the cold weather had already turned the leaves a fiery red and the architectural effect was worthy of a photograph.

For several days we had freezing fog. We were living in a ghost world of silvery trees. The hoar frost was more pleasing than the snow and without its deplorable tendency to turn to dirty-grey slush. The lane was immaculate and the winter sun flashed from one tree to another as we drove homewards. The stone badgers at our entrance gate sparkled in the chill, their chins still black where the frost hadn't reached them. The backs of each stone badger glistened as if it had emerged from wet undergrowth. Although the trees were bathed in sunlight, it was the lower branches that lost their frosted look first, as the sun is lower in the sky that time of year.

In the depths of winter the rich reds of autumn give way to softer hues. The most dramatic change occurs when the leaves fall from the deciduous trees. The scene changes from one of startling reds and blazing golds to one of misty soft fawns and purples, greens and greys. The winter light is clear and the trunks of the silver birches are snowy white from top to bottom, perfect against a clear blue sky. There is a great sense of space as I look past each black-silhouetted tree far into the wood. Normally the canopy of trees hides the view.

We walked to Brightwell on Boxing Day, taking Bracken with us. It was not often that a December day was as cheerful as that. The sun, low in the sky, cast a soft orange glow behind the dark skeletons of the trees, like the embers of a fire that had almost burnt out. Bracken was much better behaved with Tony and stayed by his side, walking sedately to heel.

That year we observed the growth and development of One-Sided-Flash's and Jess's offspring, totalling twelve between them. Of the twelve, three were known to have died that year and two had not been seen recently. We came to the conclusion that One-Sided-Flash produced one cub with defects and that Jess produced five with defects. We found the bodies of two cubs in the woods (Powder-Puff and Ginger), both of who had contracted mange.

Later an RSPCA officer caught a severely handicapped fox in the trap: it had lost the use of its back legs and was extremely thin and weak. This also had mange and was too ill to be taken to Les and Sue Stocker.

The calendar year had almost ended, the season tightened its grip and it was easier to attract the birds and animals to the supply of food. A green woodpecker swooped low over the garden, his yellow-green plumage alight in the December sun. He would soon find it difficult to go anting in the lawn and he was one bird that I would be unable to provide for. The two other

species of woodpecker, the lesser and the great spotted varieties, had already sampled the fat that had been pushed into holes bored into a dead stump.

Not all the birds are resident: some, such as the grey heron, merely fly over and others arrive from foreign parts. The birds are attracted to the sanctuary as a habitat and food supply. The shrubbery provides cover, the pond and streams provide water, and the shrubs, berberis, brambles, guelder rose, hawthorn, hazels, hollies, rowans and oaks provide berries, nuts and fruit. If the seed heads are left on sunflowers, teasels, lavender and other such plants, goldfinches, greenfinches and other seed eaters will feed on them.

I no longer fed the cubs; they hunt for themselves. Feeding would resume once breeding began in the spring and would last until the new cubs were about three months old. It would be those foxes that would bring the following year's cubs to the sanctuary. I eagerly awaited the birth of a new generation.

Tansy was more difficult to observe than the other teenagers. She was very cautious and would only occasionally come for food, making me think it was unlikely that she would bring her cubs close to human habitation. But I was prepared for the long night vigils in order to obtain information and complete my observations to satisfy my own curiosity.

I looked forward to spring and the arrival of new fox cubs, bringing many opportunities for filming. The year had been very successful — both for the hotel and for ourselves. So many things had happened that it was

impossible to write everything down. This book only records the main subjects: the wildlife around the hotel. I have tried to narrate simply and accurately the chief episodes in the lives of the wild animals, birds and insects which I have observed and recorded day by day and, when possible, with my camera. Since we are lucky enough to live in a woodland environment, I have described some of the more interesting plants that I have seen and studied.

The reader's tour of the sanctuary is now complete, but as ever with Nature, the story has no ending. There is always something happening that demands to be photographed or recorded, and I eagerly look forward to many more years of observation and insight — wherever I may be.